MASKS
OF THE WORLD

MASKS
OF THE WORLD

AN HISTORICAL AND PICTORIAL
SURVEY OF MANY TYPES & TIMES

BY

JOSEPH GREGOR

DIRECTOR OF THE THEATRICAL ART SECTION
NATIONAL LIBRARY, VIENNA

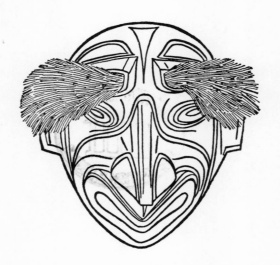

BENJAMIN BLOM INC.
NEW YORK / LONDON

First Published London, 1937
Reissued 1968
by Benjamin Blom, Inc., Bronx, New York 10452
and 56 Doughty Street, London W.C. 1

Library of Congress Catalog Card Number 68-18150

Printed in the United States of America

THE PRESENT BOOK is the result of many years' work in a field to which my previous researches had given me only indirect access. I must at once admit that I do not pretend to have given an exhaustive account of the nature and content of the Mask, nor can I offer a new theory to replace those already in existence. Neither must the reader expect to find here reproductions, descriptions, and interpretations of every single mask that has ever existed, past or present. Such a task would lead us far beyond the scope of a single work, nay of a single lifetime. I am perfectly well aware, as the course of this enquiry itself will show, that the majority not only of the objects but also of the methods of research in this field belong to a science already highly developed, and accessible to me only as a guest: to the science of ethnography; and I have no intention of overstepping the bounds of hospitality.

On the other hand it is obvious that we are here concerned with a subject which belongs par excellence to the favourite class of borderline subjects. Not only have the greatest periods of plastic art always shown a marked attraction for the mask; but they have also (especially in European antiquity and in Japan) envisaged and cultivated the sculptured mask as a special genre side by side with their main task of representing the human body and countenance. Indeed it has often happened that the individual human face is spoken of as a mask, and that the mask has been regarded as the more capacious reservoir from which individual needs are upon occasion satisfied. It is no contradiction to this principle that in the west the sculptured mask should finally have atrophied in its search for a universally valid type, whereas in the east it was precisely the search for a type that led to the highest degree of individual expressiveness (compare Rome with Japan). We shall have to show that in spite of the vast difference between the limiting conditions, the impulses were the same; in view of the immense range of Hellenistic-Roman portrait-sculpture the sculptured mask was predestined to decay, whereas in Japan all the unrealized and inarticulate subtleties which had never found an outlet in the portrait concentrated upon the mask. In contrast to these two examples French and German Gothic reveal a spiritual stability which cannot endure that certain parts should be neglected, while others are all the more copiously emphasized; with the result that we have as much (or as little) right to talk of Gothic mask-sculpture as we have to talk of Gothic portrait-sculpture. The same otherworldly perfection

reigns in the gargoyle on the cornice as in the saint's countenance within the cathedral; but the artist is concerned neither with deliberate mask-making nor with individualized and specialized portraiture.

The same borderline case, though obviously in a much more explicit form, obtains in the theatre. While the sculptor is only occasionally aware that he is carving a mask, the theatre is perpetually and exclusively under its sway. The layman is aware, as far as Europe is concerned, only of those especially intensified phases of development, such as during antiquity from the fifth century B. C. to the rise of the Christian era, when the actor played in a mask. This usage seems much stricter than that of the east, where the mask always tended to merge in a greater or lesser degree with make-up and to alternate with it, as in the modern theatre throughout the world. The exclusive devotion of the Greek and Roman theatre to the plastic mask had the following result: that with the change to the Christian world its daemonic quality was recognized—that quality which the Phlyakes had underlined by their intensification of the erotic character of the mask. At this point two currents set in: in its own proper sphere, from Asia Minor to Rome, the mask is banned; it spreads only in those outer regions, from England through Germany to the boundaries of Christendom, in opposition to the new tendencies of the time, and it regains its vitality from that moment when the forces that resisted it begin to ebb. In the Christian Middle Ages the mask led precisely the same phantom life as the other great spiritual relics of antiquity. In the sixteenth century, however, it suddenly takes on a new life; and spreads not towards the east once more, but on the contrary resumes its interrupted path towards the north and crosses the Alps into the heart of its old anti-Christian domain.

It would have been possible to make this observation without believing in the importance of the borderline subject which concerns us here, and indeed without assigning the mask any importance of its own beyond this subject. What must astonish us, however, is that more than a generation ago Leo Frobenius was able to draw a map of Africa showing the interplay of masks, which revealed not only the same number of centres but also the same directions and reactions of influence (Ursprung der Kultur I., Berlin 1898, p. 332f.). According to his researches upon masks and secret societies, the African mask has two centres: one in the south-east (Xosa) and the other in the delta of the Niger (Calabar). The first centre exerted its influence as far as the delta of the Niger—that is, north-westwards— and the second a similar influence in the same direction, as far as Senegambia; from both limits the stream then flowed back—that from Senegambia stopping short at the delta of the Niger, and the other reaching about half way back to the south-east. Even with the fullest consciousness of internal differences between these two examples, we cannot help being surprised at the similarity in the direction of the streams and of their percussion and repercussion. The main stream may be compared with the movement from the first centre (Greece) to the second centre (Rome) and from there onwards across the Alps, and the reaction with the influence of the daemonic masks of the north, which were never given up even in face of Christianity. But the analogy goes still further: The same student has observed the wavelike

6

influence of the straw and wooden masks in the west of North Africa, which doubtless follows the same southeasterly-northwesterly direction.

In searching for the locality of the most frequent and effective masks in the world, we must give Melanesia a place in the first rank. Here too it is at least conceivable that the development proceeded in the characteristic direction. In this case there is agreement with the well-recognized parallel between Melanesia and West Africa, Polynesia and East Africa, in that the two first regions were rich and overpopulated, the two second desolate and abandoned. It may be that European masks are also to be derived from a region to the south-east of us, as yet unknown.

These observations have already induced me to present elsewhere in a more cautious manner my views on the mask as the source of all dramatic activity (Weltgeschichte des Theaters, Vienna 1933, chapter III); the examples quoted there do not, however, go beyond a few general analogies. I was conscious, of course, that I must first collect as much material as possible, and from as wide a possible choice of regions and functions. I aslo realized that the great vogue for the mask which has developed in the last twenty years must also be bound up with the more general laws of this subject. A mask made nowadays, whether as a work of plastic art or for a definite theatrical purpose, must be subject to the same condition as the masks made in the Hellenistic period or by the great Japanese carvers. Other more remote and primitive instincts, which a hundred years ago shaped the masks of the Indian races and which perhaps even today shape African masks of the highest daemonic virtue, have died out among us. A glance at the pictures in this book will be enough to show that the mysterious spirit of the mask can never be silenced, that even in effectiveness the difference between a "primitive" mask from Africa or Melanesia and a really expressive mask by a European artist is simply one of degree. The newly-awakened interest in the mask, which we have experienced in our own day and which has given this book its impetus and direction, is due not to a conscious search for so-called primitive forms after the war, but rather to the resurgence of a primeval daemonic instinct.

To have published in its entirety all the material I have gathered over the space of many years would have required a book about four times the size of the present one. It has been necessary to select. And it is necessary to indicate the principles which have guided this selection; otherwise the small amount of attention paid to individual groups might have occasioned surprise. Our primary definition of the mask, then, must be the face- and head-mask: i. e. a new form of face and head, artificially produced, meant to be worn and to alter the appearance and effect of the wearer in a deliberate and definite manner. Even the mask-costume is for the most part outside our province, although it is impossible to ignore it altogether. Nor are we immediately concerned with the countless versions of the human and animal face in architecture and sculpture, and also in decoration and adornment. Yet here again we must make an exception when, as in the case of Roman stone masks, the prototype of the face-mask is so near at hand, or when, as in the case of neolithic representations of the face, the mask has not yet detached itself as a special form from the general evolution of the human image.

I have avoided repeating material which has been amply dealt with elsewhere. For example it seemed superfluous to reproduce afresh numerous specimens of Japanese masks in a general work of this kind, since these have already been exhaustively treated by F. Perzynski (Japanische Masken No und Kyogen, Berlin & Leipzig 1925). Other parts of the world, such as the Alpine regions and Benin, are also excluded from our detailed enquiry, since the literature dealing with them is already sufficiently abundant. None the less, I have not refrained from introducing occasional examples to assist the memory and to provide comparative material. Anyone who takes the trouble to consult the literature mentioned in this introduction and to supplement the examples in the present book with the pieces published there, will acquire a thoroughly adequate view of the subject and will be convinced that our knowledge, if at present still in the descriptive stage, is rapidly becoming more comprehensive.

The division of material from such a variety of places and periods has presented great difficulties. A division by period was out of the question and a regional division was open to grave objections. For it is the aim of this book to represent the mask as a world-phenomenon exempt from time and space, as the first and strongest utterance of a universal religious feeling in art, far older than myth or saga or any other more developed form. It was my intention so to arrange the examples in this book that they formed groups coherent enough within and inseparable without. Even the least experienced observer will have no difficulty in forming the larger groups: America, Africa, the Far East, Greece and Rome, the eighteenth century, the present day, etc. But in the very act of naming them we observe how totally different are the reasons for such divisions, and decide that it is better to give up the idea of dividing them at all, rather than to risk a perpetual conflict over the terminology and limitations of our subject. My meaning will be made clear by a glance at figs. 50—53 better than by any amount of explanation. On the same plate there are reproductions of two African masks, three from Borneo, and two from Washington: between these seven masks there is the closest similarity of content notwithstanding the greatest difference of technique and appearance. The Makah stylize the wolf quite crudely by joining two carved boards together. The two masks from Cameroon and Ashanti are animal-phantoms such as are often used for hunting. From these there is an immediate link which leads to a phenomenon like our Alpine mask, fig. 180, even though the artistic quality of the African mask is higher. Technically the most advanced are the three animal-phantoms from Borneo, which in spite of the extreme physical distance are immediately comparable here. In any case the strongest impression proceeds from the objects themselves, not from any explanatory remarks about them. Accordingly we shall turn our attention primarily to the sphere where the mask is still artistically alive, namely to the theatre, though we shall seek help from the science of ethnography, whose guest I have claimed to be. For the same reason I cannot conclude these introductory remarks without expressing my warmest thanks to those institutions who have advised and assisted me in the collection of my material: especially the Museen für Völkerkunde I and II in Berlin, the Museum für Völkerkunde in Vienna, the Rijks Ethnographisch

Museum in Leyden, and the Museum of the American Indian in New York; as well as to other collections like the Museo della Scala in Milan, the National Museum in Athens, and the scene of my own work, the Nationalbibliothek in Vienna. I trust that they will not regard the scheme of this book as a device for dissipating their treasures.

As so often happens with the higher spiritual and artistic manifestations of human culture, it is impossible to define what the mask is. This it has in common with religious experience and with the nature of the drama. We can only hope to limit our definition in such a way as to enable us indicate the date of its appearance and popularity and to include as many of its uses as possible. We must remind ourselves that the understanding of music is given only to those who practise it and meditate upon it.

No limit of time can be assigned to the mask. It must have begun at that moment when the childhood of man started to exercise its creative powers in general. We all of us know that each individual experiences afresh the same creative process. The child indicates the human face as a circle or an oval, with two small circles for the eyes and a vertical and a horizontal stroke for the nose and mouth; and if leisure and talent permit, two further ovals for the ears, as well as some hair. In the majority of these typical repetitions, which every child may be seen to produce, the result is a mask, whose "style" corresponds with the ornamental scheme of the small drawings of the Stone Age. Even so good a judge as Frobenius can only answer the question why the human face so completely absorbs the creative powers of primitive man by supposing that one's neighbour's face is the commonest thing that strikes the eye. I should like to add the word "forcibly", since impressions from the plant- and animal-world must be equally common. At this early stage in the development of our theme, however, we must not ignore the fact that magic factors must also have played their part; though we can say very little about them, we must never forget that they are there. The incomparable miracle of the eye, whether silently addressing us in our fellow man or glowering bestially at us out of the jungle; the human or animal mouth, emitting sounds full of meaning and sometimes even actually intelligible; and finally the ear, which receives these sounds: all these elements possess an un equalled power of focussing the attention, since they are the agents by which magic mastery is attained. Inasmuch as the boundaries of man and beast merge into each other at this stage, we observe on the one hand the emergence of the mask and on the other indications of that animalism which in the most primitive modes of thought completely dissolve the boundaries of man and beast. The oldest monument of this kind is probably the drawings in the cave of Combarelles, which date from the quaternary, or hunting, period of the Stone Age, and show figures which turn into grimacing animal heads and can be described as human masqueraders. If objects of this kind always appear one at a time, none the less the whole of prehistoric art is full of human and animal heads, especially in those most important shorthand forms which fix and repeat such significant parts as the eyes, nose, and teeth. In the same way the student of prehistoric art can speak of "female stones", when confronted with fragments of the breast and other highly purposive parts of the body. In our province the horses' heads from Mas d'Azil are typical

masks, with their rows of ornamental teeth. Moreover, there are also the bones from Almiza-raque, with their engraved eye-pattern, the various potsherds with eye- and cheek-patterns, and finally the stone image from Collorgues, which in its desire to achieve the human face falls completely into infantile habits of expression. The highest point of this art is reached in the Nordic elk-heads from Alunda in Sweden and Hvittis in Finland, where the head is already admirably modelled in stone and served as a weapon, as the bored hole shows. The treatment of the head as a plastic adjunct designed to enrich or adorn is not achieved, therefore, as an end in itself, as in the portrait or the mask. All these stages are clearly indicated in Egyptian art, our teacher in this, as in so many other matters. Chnum is a ram, represented as a man with a ram's head: the most complete statement of that stone-age type. Just in the same manner Horus, Thout, and Suchos embody the falcon, ibis, and crocodile. On the other hand, the masks of the grotesque god Bes (figs. 76, 77), a god of marital relations and birth, are already developed works of art.

One type, however, which corresponds exactly with children's drawings and the figures of the quaternary period, and which constantly recurs in the art of the mask, seems to appear for the first time in the Bronze Age. In the finds from Butmir and Gradac, and in the seated figures from Thrace (figs. 71, 73, 74), the mask is "coined" in the simplest way, just as in childrens' modelling; the pressure of forefinger and thumb brings out eye-sockets in the clay, with the bridge of the nose in between, and a second pinch in a vertical direction (fig. 74 right) brings out the projection of the cheeks. Eyes, mouth, and teeth must, of course, be added separately. These methods last a simple art for thousands of years (figs. 70, 75).

Even the primitives of recent times proceed in just the same way (figs. 20—22); in particular we may note how the same material always dictates the same glyptic treatment. The fact that there is no essential difference between the death-masks from the gold treasure of Mycenae (figs. 90, 91) and the gold and silver masks from Peru (figs. 17, 18) bears vivid testimony to the universal validity of the mask. The difference between the clay heads to the right and in the middle of fig. 22 is just as insignificant, despite the fact that the mask in the middle is the work of a primitive hand and the object on the right that of an artist who could make the most expressive use of the smallest detail. In these latter examples I can feel no trace of the deeper significance, the magic influence, which we ought tacitly to assume in every mask. Such features might have been fashioned time and time again and still remained unmeaning, but for the sudden resolve of the human mind to lend the mask a significance which placed it suddenly in the forefront of its mental and emotional equipment.

This all-important step—one of the really decisive moves in the history of the human spirit—can only be explained pragmatically. Let us consider it again in the light of its temporal and spatial limits. Inasmuch as animism gives man and beast an equal value, the animals soon outweigh man by reason of their greater strength and superior daemonic power. The animal becomes an ancestor; and its likeness becomes a higher form of symbol (totem), which whole tribes and families hold sacred; and its flesh must consequently never be

touched. This daemonic power of the animal is expressed in its complete form in fig. 49. Masks which unite two similar individuals one above the other symbolize the sexual act, and hence a line of descent (Gregor, Das amerikanische Theater, Vienna 1931, fig. 1). In this manner complete family-trees come into existence (One of the finest in: E. B. Tylor, Totem-post from the Haida Village, Journal of the Royal Anthropological Institute, London 1899, p. 133. The enormous conglomeration of masks carries at the top a tall hat, such as the ancestor of the family must actually have possessed, since his adversary had to climb to heaven in order to cast him down into a kind of deluge). In mythical stories the totem-animal can often be seen hovering in the background. The ancestor of the Hopi was given the snake-maiden as a consort by the gods of the underworld; their children were little cobras, which, however were hunted out of the village. As a result a drought set in; the snakes had to be protected; and in their honour a festival was enjoined for several days, with dancing to induce the rain to come. Even in the most sophisticated period of Greek art it was possible to make room for these totemistic relics: the eagle of Zeus, Athena's owl, and the snake of Asklepios.

It is easy to see how daemonic powers were transferred in this way to the mask, which was closely akin to the totem-animal. But the mask does not remain at the animal stage: every sort of daemon, the spirits of the departed (cf. the skull-mask, fig. 26), and the spirits of air and water enter in and have their dwelling there. Its use becomes ritual, and the wearer of the mask becomes the daemon. Its applications are manifold: incantations and the needs of the hunter and the warrior are thus provided for (figs. 103, 104); and it is often simply the warning sign of a ruling authority, such as a men's association, which must be avoided by others, especially women, and indeed must in many cases not even be seen. The most striking use of the mask is at those critical times of life, such as the initiatory ceremonies of adolescence, when the daemons must be brought into as close a contact as possible with man. In the secret dedicatory ritual of youths among the Karesau-Islanders (New Guinea) the boys' consciousness of the spirits is awakened by striking water and tracks in the sand. The spirits then appear in person from their houses: first a taller one, Menompoim, followed by a shorter one, Wipor. Both wear enormous structures of wood and cassowary-feathers, with the addition of a fish; and they dance and sing; when they have retired to their house, other spirits appear, Man manan and Man mon, both as bird-masks, and these dance too. After this spectacle the initiates are denied the enjoyment of the flesh of both birds and fishes (P. W. Schmidt, Anthropos, Revue internationale d'ethnologie. St. Gabriel, II, p. 1029). It is of great importance that the daemons should not be seen by the uninitiated and by women; and heavy penalties are prescribed for the breach of this law. In the dance-festivals of the Monuruba-Papua (New Guinea) the dances are performed by a series of murupika (spirits) and nassaranga (uncanny beings), cassowaries and dog-masks; the reporter states explicitly that the mystery was transferred to the masks themselves: which explains why they were to be shielded from the profane eye (P. F. Vormann, Anthropos, VI, p. 419). In the puberty-festivals of the Nor-Papua the costumed figures dance wearing the mask of

the water-spirit (igbrag). The mask, the lance, and the flute represent cult-objects of the highest importance: the voice of the spirits lives in the flute; the lance is merely a convenient substitute for the much too heavy mask (Fr. Joseph Schmidt, Anthropos XXVIII, p. 321, with reproductions of the masks). In the hero-cult at Cape York daemons appear in the following masks: 1. I'wai ceremony: horns made of grass and a robe of the same material; the mask of eucalyptus, red painted with ochre. 2. watu: bull-robe; painted mask with wooden teeth, tufts of feathers on the head. 3. the mask consists of a tall wooden cylinder; then come great devil and kingfisher-ceremonies—in these a Kainnadjie pantomime, in which youths impersonate their ancestors. First comes the beating of drums and the women's dance, and then the young men appear as kangaroos. sniffing and pawing and raising their heads suspiciously in the air. The mask is painted white and red, with big ears, and the kangaroo's pouch hanging over the breast. At a sign from an old man: Stand at attention— there is a short wrestling-match. (D. Thompson, Journal of the Royal Anthropological Institute, 1933). The masks are in no case rigid; as double masks they are also double beings, often with movable mouths which contain a second mask inside. K. Macgowan and H. Rosse (Masks and Demons, New York 1923), in a collection of 175 examples, describe a mask from British Columbia, which represents a deity outside and opens to reveal a bird, in which form the deity flew down to earth; and which then opens again, disclosing the head of a man, the final transformation of the selfsame spirit. Thus the whole myth is embodied in the mask.

In the last-mentioned ceremony the youths understand its representational character clearly enough; but there are many cases where the secret character of the rite is carefully preserved and the initiation-ceremonies symbolize annihilation and rebirth. Hutton Webster (Journal of the Royal Anthropological Institute, vol. 41, p. 482) reports that in the western islands in the Torres Straits that the behaviour and habits of the dead man are represented in clothes and masks. Women and children must keep their distance, since it is believed that they are dealing with real ghosts. In these examples the cult-character disappears more and more; Martin Gusinde reports that in the secret ceremonies of the Indians in Tierra del Fuego the members of secret societies wear masks and "play at ghosts", merely to frighten the women. From this apparently close contact between men and spirits arises the superiority of the former over women (Mitteilungen der Anthropologischen Gesellschaft, Vienna, vol. 60, p. 352). The medical aspects are discussed by W. L. Hildburgh (Journal of the Royal Anthropological Institute, vol. 38, p. 148). The daemons dance by night in red, black or dark blue, and white garments. They plague sick people, or suffer from the same disease as they do; and there are also arch-devils who control the others. The number and enumeration of the daemons depends upon the wealth of the sick man and the gravity of his disease.

If we glance over a part of the masks here brought together, there is much that at once becomes clearer. The animal nature of figs. 6—8 is immediately obvious. In figs. 11—16 it is intensified to the point of absorbing the fragments of the original animal. In figs. 1, 4, 5 a

new artistic trait makes its appearance: the masks are provided with added ornament in the form of a radiate crown or mane. At the same time we may see the arrival of that polychromy which makes the strongest impression of all: the rings round the eyes, the exaggeration of the mouth (figs. 9—10), which in our eyes produces a completely bestial effect, and the decoration of the cheeks, so important from the ethnographical point of view (fig. 19). Now the artistic mask-makers appear on the scene and paint the mask in a tasteful manner (figs. 23—24). The usage to which the masks are put (so far as this is discoverable) is to be learnt from the inscriptions; the technical material embraces all the animal and vegetable substances accessible to the craftsman. The strongest plastic effect—almost monumental in degree—is attained by the masks of the Laos country (figs. 38, 41), those of Cameroon (figs. 42, 43), and also those of Nigeria (figs. 46, 47). The masks used for warfare and hunting and medical purposes form a class by themselves (figs. 186ff.). Since the disease is the work of a daemon, and the daemon has his dwelling in the mask, he is also to be expelled by the use of the mask. The same is true of the shamans for protection against evil spirits (fig. 55).

Truly remarkable descriptions of the religious dances of New Ireland have been given by P. G. Peekel (Anthropos, vol. 26, p. 513), who also reproduces the masks (cf. our fig. 60). These dances might be described as pantomimes on a grand scale with an elaborate story, in which, by contrast with the first examples, with their strong cult-character, the magic motives are only just perceptible. In the shark-dance the sharks and their hunters appear in masks. In one of the longer dances (whose choreography Peekel has carefully described) the capture and death of the shark is enacted. Thus they bring back animals to life with ceremonies and dance-movements of a most effective kind. In another pantomime the phases of the moon are made to dance, typifying the belief in death and resurrection and the higher lunar mythology (for the solar, see Frobenius, Ursprung der Kulturen, p. 319: Shango-myth). In these pantomimes from New Ireland, whose masks are sometimes so enormous that their wearers can only move with the greatest caution, we have undoubtedly already reached the theatre. The primitive myth has already become representable, but still continues to use the daemonic apparatus of the mask. The transition from one conception to the other has been very acutely defined by Frobenius (Paideuma, Munich 1921, p. 49): "The young people said: 'a leopard circumcized us—he was the dead king.' The old people said: 'when the priest as leopard circumcizes the boys, he is the dead king'." (for the leopard and all the masks of the Belgian Congo, v. J. Maes, Aniota-Kifwebe, Antwerp 1924, with numerous examples, cf. our figs. 25 and 45).

Even so superficial a treatment of so small a number of masks is enough to give us some notion of their nature. We may regard it as an axiom—and this applies equally to the theatre —that the wearer of the mask wishes to be identified with the character he represents. This identification is achieved by music and mimicry; it attains a high degree of plausibility for the unmasked, with the assistance of taboos and other restrictions, and becomes completely convincing in the case of war-masks and incantation-ceremonies; in the former the wearer wishes to be stronger than his enemy, and in the latter stronger than the daemon himself.

13

A very considerable force must therefore be compressed into the mask and emanate from it. This is nowhere stronger than in the masks from Africa, which for this reason are somewhat more plentifully represented here (cf. Frobenius, Kulturgeschichte Afrikas, Vienna 1933, which contains a comprehensive section on the mask; see also A. Mansfeld, West-afrika, Berlin 1929). From the total number of examples adduced two cases keep recurring, which seem to me to show two diametrically opposite uses of the mask: its use in puberty-ceremonies and its use in pantomimic dances. In the former case the mask emphasizes the theme of death and rebirth, the central problem of primitive thought. The boys who are subjected to the ceremony of initiation on reaching puberty are to be annihilated and then recreated. We know with what solemn, indeed gruesome, means this is often accomplished; and we also know that with the attainment of manhood are associated the most important phases of life: the entry into the men's quarters and the cohabitation with girls. The extreme vital significance of this event is mitigated by the use of the mask in secret fellowships to the point at which the mask seems to be little more than a purely symbolic parade-uniform of menacing import to those who do not wear it. The significance of the mask reaches a completely new phase in those pantomimic representations, with their daylong dancing and feasting, whose original daemonic character has faded and been converted into a fixed meaning. But we must always remember—hard as it is for a European to realize it—that from our point of view it is impossible to see the mask correctly, with its intimate relation to nature and the exotic surroundings in which it arose. Like clothes and weapons and many other objects of artistic and private life, which lose their meaning when uprooted and torn from their context and brought to Europe, the mask suffers particularly, not only as an object partly or completely dedicated to cult-usage, but also on account of its close connexion with the living organism, with specific movements and articles of clothing, with the background and with light itself. There is no such thing as a mask which ought to be seen as a picture shows it: naked, without all its wealth of accessories; and hardly a mask which we can understand merely by taking it in our hand, without knowing anything of its use. Especially instructive, from this point of view, are those rare occasions when we see masks used, whether outside Europe or at home; the smallest face-mask—a dead thing when it merely lies before us—gains immensely in importance when it is worn at Carnival. Can we take the step of imagining the gigantic masks of New Ireland, the mighty and massive masks of Africa, the magnificently carved masks of the Indian races when used in their own environment near the primeval forest, with a mysterious light playing upon them, hardly to be conceived of here, and worn by bodies with an extraordinary wealth of natural movement and at one with the spirits which believe in their daemonic power?

Yet it is precisely this pneuma—I use intentionally the phraseology of the mystery-religions—which we must imagine as filling the mask, when we attempt to answer the question which I believe must occupy the centre every of discussion of this subject. Is the mask which we find among so-called primitive peoples almost without exception all over the world something entirely different from the European mask, whose existence is less astonishing

and whose development is more familiar to us? Even Europe is no stranger to the mask; we know of its use in antiquity and have made up our minds (though only in the last few years) that this mask is not essentially different from that worn in the theatre and at carnival from the Renascence to the present day. We then cast our eyes over an almost illimitable field when we consider the use of the mask in architecture and sculpture; and the ever-increasing enfeeblement and stylization here prevents our remembering that this is in fact the same object that we encounter in so formidable a shape outside Europe. At home the mask meets our eye for the first time in the Greek theatre; and here already it has lost a great deal of magic power compared—let us say—with the temple-pantomimes of Bali or even the No of Japan, not to mention the devil-dances of Tibet or the already-mentioned lunar pantomimes of New Ireland. To a large extent the reason for this is we do not know the Greek mask at first hand; it has survived only in those derivative forms which must have lost much of the original p n e u m a. On the other hand we possess a whole series of old Japanese woodcuts of representations of No plays, which reveal masks of a far more vividly magical character. The marble imitations of the Greek mask naturally retain none of this magic effect; only in the P h l y a k e s, as we have already observed, does the grotesque animal eroticism of these plays lend the mask a certain daemonic virtue.

It is a striking testimony to the fearless logic of science that the most difficult step in our entire problem has been surmounted by the tireless efforts of ethnographers and historians of religion and that the congruity between the religious notions of recent "primitives" and of the ancient mysteries has at length been established. The difficulty has been greatly increased by the fact for the first half of our comparison an ever-increasing quantity of good ethnographical material was available, whereas the evidence for the ancient mysteries is notoriously late and scanty. None the less, admirable results are already available; and I quote them here because they answer the most important question as to the connexion between the masks of Europe and those of the rest of the world. The first crux lies in the interpretation of those initiation-ceremonies, with which, as we know, the whole apparatus of masks is closely connected. In Sparta too the ephebes were scourged at the altar of Artemis Orthia, just as they were grievously maimed and tortured in puberty-rites elsewhere. In Sparta too the priestess of Artemis stood by, weighing a wooden image, which was heavier or lighter according to the heaviness or lightness of the boys' ordeal; the same ritual is found in Samoa. The erotic freedom associated with this dedication is also to be remarked in China, at the capping ceremony. Initiation into the majority of Greek mysteries—those of Eleusis, those of Isis, and those of Mithras—was preceded by a purification which we find again among the Maori of New Zealand. The mysteries of Isis and Osiris are noted for their fasts, whose regulations can be paralleled elsewhere; still more notable is the analogy between the stigmata prescribed in the mysteries of Cybele and Mithras and the piercing of the penis in those of Papua and elsewhere. It is also probable that the bull-roarer, so common in Africa, America, and Oceania, in order to warn women away from secret rites, was not unknown in Greek mystery-cults. The parallels are especially noteworthy in rites which relate to the

central notion of death and rebirth. So far I have taken my examples from the admirable work of C. Clemen (Zum Ursprung der griechischen Mysterien, Anthropos, vol. 18/19, p. 431); I should like to add that the clearest case of the parallel between the baptism of blood and the conviction that the mishandling of the boys involved their ritual death and resurrection seems to occur in the Phrygian rite. Here the mystes descended into a pit, over which a bull was slaughtered; when the blood poured down upon him, he was reborn. The symbols of the god are the snake and the fish—the latter surviving in the Christian mystery. In this connexion I would cite once again the snake-dance of the Hopi and countless totemistic masks. In the mysteries of Sabazios, the snake, which represented the god, was drawn through the lap of the mystes, to signify his union with the god. In Eleusis the climax of the festival was the moment when the priest cried out: "A holy child is born to the highest one (Demeter)." Thereat the mystes knew that he too was reborn, like the youths of Papua, who know that they may at last enter the Mogin-house. The priest of Demeter, however, was withdrawn from the company of men and lived apart with the heavenly ones, just like the wearers of the sacred animal-masks. (Marked, rather than masked, as the Leopard, as Frobenius appositely observes). In our knowledge of the use of masks in the ancient mysteries we can, however, go a step further; Clemen points out that the animal-names associated with the Mithraic system correspond with the imitations of animals on the upper Zambesi, and even that (according to Pausanias) there is no doubt that at least the priest of Demeter at Pheneos wore a mask. At this point we cross the dangerous threshold and can demonstrate the magic use of the mask in our own cultural region. A further step is taken by G. Roheim (Dying Gods and Puberty-Ceremonies, Journal of the Royal Anthropological Institute, 1929, p. 181), when discussing the central doctrine of Greek rebirth, the rending asunder and resurrection of Dionysos; he draws ingenious parallels between the structure of myths in various parts of the world—"A great man (such as Kronos) lived in far-off days and taught the rites of initiation; he killed the boys, but two of them escaped and killed him" (Mungarai); "A young man sang so beautifully that all came to listen to him; he died after indulgence in fish and was burnt; from his ashes grew the paxinba-palm, out of whose wood were carved flutes which repeated the dead man's songs." (Yakuma, South America). It is almost certain that the more closely we investigate our own mythology and compare it with that of primitive peoples, the more light we shall be able to throw upon the origins of our own culture.

Shortly before finishing this work I have been able to add an example proves the continuity between the religious conception of the mask in antiquity and in the middle ages (fig. 122). In the Museum of Catalan Art at Barcelona there is a twelfth-century fresco from Santa Maria de Tahull which shows the evangelists' animal symbols in such a way that winged human angels' figures support the heads of the lion and eagle with a surrounding aura. In the eagle's head especially there can be no doubt that the painter wished to indicate a head-mask, whose attachment is still quite clear to see. There is no formal difference between these Christian representations and those of the Egyptian deities Sachmet (Lion), Harachte

(Hawk), Hathor (Cow), Thout (Ibis) etc. It would be possible to demonstrate irrefutably the tradition persisting from ancient down to medieval times.

Nevertheless, the daemonic character of the mask was as uncongenial as possible to the Greek genius—by which I mean the classical Greek genius from Homer to Alexander the Great. To imagine the gods of Greece as masks is a contradiction in terms; the liberation of their countenance is, on the contrary, the first great triumph of the occidental European spirit. Helios himself has no African parallel: the aforesaid Shango, whose servant is the rainbow Oshumare, whose messenger is the thunderclap Ora, whose three wives are the three chief rivers of Africa, and who descends to earth, leaving a chain behind him: the path of the sun—in Shango as in Helios the sun-myth has triumphed. Yet the conception of the sun's chariot and its pinioned charioteer leaves all others far behind in artistic and human power. Greek religion marks an absolute climax, like Phidias who created its temples. The mystery-religions reached their prime only when the flower of humanity was fading; not till then did the cult of Demeter flourish, and the cult of Isis not till Roman times. The Roman legions, in their quarters on the German frontier, paid their honour to Mithras and voluntarily submitted to the most terrible tests of valour, thereby discovering the initiatory rites afresh. The last of the mystery-religions, Christianity, had no easy task to assert itself.

Considerations of this kind make us understand why the mask, that relic of prehistoric dread, lost ground where Katharsis, purification by destiny (note the conception of rebirth) held its own in the theatre. And it is amazing to realize what a wealth of daemonic energy still lives in the Greek mask—and that too before the moment when the classical dramatic mask cut itself adrift, before the moment too when its magic returned—namely in the Hellenistic age. The Gorgon (figs. 78—80) is the mask of the primeval Greek world. Yet Perseus struck it off and fastened it to his shield, thereby stylizing it and rendering it harmless. It is worth noticing how ready both types were to find room for those animal traits which always provide the foundation for the mask-ideology: the older (figs. 81—82) and the newer alike (figs. 108, 110, 115). Here too, however, the triumph of humanism is overwhelming, refined to those last perceptible perfections—the tragic and the comic types—in whose pure simplicity the Greek spirit expressed itself.

It is hardly possible to gain a deeper insight into the nature of the mask than by comparing the experience thus acquired with the utterly different interpretation which the Far East put upon the theatrical mask. Leaving aside the ethical and aesthetic differences, let us consider merely the outer form of the mask. We observe in Siam (figs. 195—198) the same type-formation as in Hellas, with the difference that the fundamentals are not emotional, but racial. The notion of community of descent (caste) outweighs every psychological consideration. Manusaphong (human), Vanaraphong (simian), and Asuraphong (giant) are the categories which appear in the masks and producers' handbooks (cf. K. Döring, Siam, Darmstadt 1923). The mask achieves the same absolute perfection of type as in Greece, in spite of the most extreme differences in the modes of stylization. It would not, perhaps, be too bold to maintain that the surprising fact that the mask in the theatre is confined to men,

the women remaining maskless, is due to the influence of the exclusive right of mens' associations to wear the mask. It is no objection to this principle that Totsakan should wear a gigantic gold mask (fig. 195) when conversing with his consort Nang Munto, who wears merely a head-ornament, but otherwise nothing over her face. India and China attach explicit importance to the colours—a clear sign of abstraction from a once more sharply emphasized system—but I can trace no essential difference between the tremendously expressive grease-paint masks now in use (figs. 208—211) and the plastic face-mask, especially when the grease-paint mask is reinforced with abundant decorative accessories. The artist responsible for these masks is even today so impressed with the importance of colour that he explains fig. 211 in the following fashion: "When representing In-kao-so, who lived in the days of Chun-Tsio, a great statesman inspired with a special reverence for his parents, and hence exercising a particular influence on the emperor: for this reason, black-red." The notion of colour quite replaces the notion of form. Incidentally it should be noted that fig. 210 represents an ape-spirit, an animalistic conception which never disappears from the mask in any circumstances. This conventionality, which gradually robs the mask of its daemonic power (figs. 216—218) reaches heights of human expressivenes (cf. figs. 215, 219 with 220) without ever quite losing sight of its animal ancestry (fig. 221). For this we must cast a glance at the art of Japan.

The antique mask lived on into the middle ages and was propagated by manuscript tradition (figs. 119—120). The Christian mystery could not do without its daemon (the Devil), and was therefore forced to reach a compromise which admitted the animal daemon-mask once more into its iconographic scheme. For this purpose the horned daemon of the modern "primitive" lay ready to hand, just as in the Far East (figs. 181—182: cf. figs. 218, 222); and there seems no reason why we should not see signs of secret associations in the masked dancers of Europe. Just as in Siam contamination takes place, and in the new mystery the mask of the animal-daemon invades the realm of the divine and saintly figures, who appear as the bland maskless forms of classical antiquity (figs. 123—124). But even the animal daemon could also rise to artistic heights, just as in the Japanese art of the mask: cf. fig. 182. Moreover, the available stock of mythical masks is by no means limited to the animal-daemon; countless grotesque possibilities lay ready to hand, from the half-bestial fool (figs. 134, 139, 140) to the grand satyr-like child of nature, the Wild Man (fig. 133). It would be possible to multiply examples indefinitely: I have chosen only those which afford good comparative material. Note, for instance, the resemblance between the fourteenth-century ridge-tile from Würtemberg (fig. 133) and ancient acroteria (figs. 81, 82). But by the far the most significant fact, as I see it, is that the Christian mystery made use not only of the negative daemon-mask but also of the highest symbolic figures: Christ as the Lamb, the Holy Ghost as the Dove—these figures point us towards a familiar region, yet the ideal stamp of the features is as striking in the case of masks representing the Saints (figs. 125, 127) and Christ himself (fig. 128), as in those which symbolized Dionysos (fig. 118) or Athena (fig. 105, 106). There is no religion which can dispense with the mask, since there

18

is no more vivid expression of magic power than the features of the good or bad magician. Here too the experience of ethnography is illuminating: the mask is sometimes represented by other objects, such as lances and flutes, but no more than represented. Cabalistic signs may serve to exorcise a spirit, but the spirit is once and for all the "face".

The same trait that joins the new mystery with primitive and popular mythology joins it again in the sixteenth century with the reawakened mythology of antiquity; and to this double relationship is immediately due the culminating achievement of the European mask. The spirit who borrows his chequered suit from the racing wisps of cloud is no creature of our Germanic past, but a creature of today (fig. 143). He borrows his lineaments from the Roman phallophorus (note animal mouth and the painted eye-sockets of the figure to the right). Such is Harlequin's ancestry: so too Brighella is descended from the slave in the New Comedy, Pantaloon from the Atellane farces, Pulcinella from Maccus and Buccus. This is no place to discuss the origins and affinities of the Comedia dell'arte; the literature on the subject is abundant, and from it I have taken most of the comparative material for figs. 148—177. For comprehensive accounts of the subject I would direct the reader to M. von Böhn, Das Bühnenkostüm, Berlin 1921, and P. L. Duchartre, La comédie ita-lienne, Paris 1924. My own views are stated in my books Das Bühnenkostüm, Vienna 1925; Weltgeschichte des Theaters, chapter VIII; and Denkmäler des Theaters, Munich 1924ff., part VIII. It is astonishing what an influence the comedia dell'arte exerc-ised upon the whole of contemporary art, from puppet-plays to porcelain and even to respectable sculpture on a large scale, from the impromptu to the easel picture. No less remarkable is the persistence of that little object, the face-mask, which now leaves the mouth free, as though to disclaim its animal origin, and which now abandons the traditional mate-rial of wood or leather for a light slip of stuff. Yet conventionalization again sets it, and in content, not in form alone. For the third time in our experience the process is repeated which we have already witnessed in antiquity and in the Far East. Whereas the Renascence, in its excitement at rediscovering a mode of expression, created types for every possible occasion (in the Florentine carnival there are even masks for the mathematical sciences), the Venetian mask of the eighteenth century was generalized into a single masterly type.

The Venetian social mask dispensed with individual expression (see figs. 146 and 144), and yet it is daemonic in the highest degree, because its whiteness and its beak-like nose give it the look of a mischievous bird, such as a raven. Remembering that this bird-nose is by no means confined to Italy, I should be more than half inclined to associate it with those all-knowing birds of Germanic mythology. For the Venetian mask is all-knowing, inquisi-tive, and curious. It stands for the breakdown of every social restraint; and it implies, without a doubt, some secret society. It is enough to slip into the ample cloak of invisibility, to don the three-cornered hat, and to poise the beak in front of one's nose, in order to become unseeable and uncontrollable. It is fantastic to read of the thirty thousand masks that descended in a swarm upon the Piazza. A secret society on such a scale could hardly fail to set the tone and endanger the lives of those who went unmasked; the penalties would be

19

on a par with those meted out in primitive societies to those who profane the mysteries of the mask. Moreover, the Venetian mask was by no means confined to the carnival and the ballroom. It was worn to the theatre and to clandestine assemblies; it was worn by those who walked abroad to quiz and be quizzed; and those were not few who wore next to nothing beneath and found their mask protection enough.

It is not surprising that such an apparition called forth curiosity about the whole subject. Interest in the mask begins with the eighteenth century: with the compendium of F. de Ficoroni, Le maschere sceniche e le figure comiche d'antichi romani, Rome 1736, a work which has not lost its interest for the student of antiquities and masks alike. Here we find, especially in carved stones, much that seems familiar enough, and serves to remind us of the immense scope of the mask. The helmet-mask cut in topaz (xxx), the double masks of various shapes, but especially the mask that carries another in its mouth—a bearded man without and a child's face within, in chalcedony (lxxxiii). Even earlier, in 1723, there appeared in Frankfurt and Leipzig an extremely learned treatise by Chr. H. von Berger, which is of the greatest interest for us, since it plays an introductory role to Goethe's Taschenbuch der alten und neuen Masken (1793). The wonderfully lively description of the Roman carnival, which Goethe has set down here from his his own impressions, not only introduced the subject betimes to the German literary world, but also enjoyed an uncommon measure of success in the home of the carnival itself. The treatise reappears on the scene, as is well known, in many of Goethe's later works, as well as in the famous Abhandlung über die Comoedie aus dem Stegreif und die Italienischen Masken by F. Valentini (Berlin 1826), with its magnificent coloured plates which far surpassed the modest coloured engravings in Goethe's Taschenbuch. Goethe had already been struck by many of the masks which reappear in Valentini's book, and which even today provide material for thought. He had noticed the costume of the female Pulcinellas, which Valentini represented with great charm (fig. 176), and the multitudes of Pulcinellas in general, whose royal entry is reproduced in fig. 177. The use of the mask as the badge of a fellowship is here unmistakable; it recurs, too, in our fig. 166. There is a whole series of drawings by Tiepolo which deal with the adventures and tricks of these Pulcinellas. Goethe also noted an animal mask, Punchinello as Cuckold: "The horns were movable; he could draw them in and out, like a snail. When he passed beneath the window of a newly-wed couple, he let one horn show a little; and under another he would shoot both out at full length and the bells fastened to the tips tinkled gaily, so that in a moment the public was all agog, and there was often much laughing." Goethe has left us a great deal of material for the study of masks which it is pleasant to work out. He was particularly struck by the quacqueri, prettily dressed little masks with brocaded or embroidered waistcoats; Valentini has reproduced some of them. The peculiarity of these noisy fellows consists in their little puffed-out cheeks, with a fat round nose between: a sort of frog-mask, in other words, accompanied by a special shrilling sound which ran up and down the Corso. Goethe compared the quacquero with the buffo caricato of the comic opera, especially on account of his nonsensical character. In point of

fact, the mask of the quacquero, as our fig. 33 shows, is of very widespread occurrence and belongs to the common stock of the mask in all parts of the world. The Roman carnival contributed to the mask-scene in the first act of the second part of Faust; just as Goethe has left us a descriptive document for the history of the eighteenth century mask, so he has created the greatest poetic interpretation of the mask in modern literature.

The age which witnessed this creation was, however, unfavourable to it. Nothing could have been less congenial to the rationalistic nineteenth century than the mask; and it became the plaything of carnival-time and the badge of the buffoon. In the theatre the mask is found only in opera or ballet; the public at large knew it only as a child's toy, as the grotesque insignia of the circus-clown, or finally in the degraded form of a Roman tragic or comic mask in some decorative stucco pastiche. These ridiculous relics are not without interest, however; and it is significant that in the carnival during the closing years of the last century the mask gradually fell out of use, and the word was falsely applied to the domino, not to the essential feature—the transformation of the face. Only in Alpine countries did the mask retain its traditional form with a persistence equal to that of Africa, America, or Oceania. And even here the zeal of travellers and collectors, colonizers and missionaries, did its best to drive it out of existence.

It is one of the strangest facts about our recent past, that the experiences of Europe during the past two decades have radically altered this picture. Not only has our knowledge of the mask increased, as the numerous scientific publications on the subject bear witness; but our sympathy has increased too. Plastic artists in all countries have with one accord turned their attention again to the mask. It is no longer unthinkable, as it was under the sway of the naturalism of the turn of the century, even for an actor to play in a mask instead of a wig and grease-paint.

This change of mind is certainly not the result of a mere accident. In the first place even the remotest countries have come nearer to us—almost too near, for in the years directly after the war we were overwhelmed by a flood of Americanism, which characteristically enough brought with it far more of the art of the negro than the art of primeval America. This exoticism fell on surprisingly fruitful soil; exhausted by the individualism of the pre-war era, which had led to countless styles and experiments in the theatre, taste now reverted to the collective, to the dynamic, to the choric; and the natural costume for this stylized art was the mask. Since there was now a great vogue for dramatic dancing, as distinct from the ballet, the mask was welcome as a means of depersonalizing the chorus and assuring its generalized value. The danced myths of the primitive peoples had found the mask ready to hand; the new dramatic dance had to rediscover it—no easy matter, when both myth and mask had to be invented at the same time. The general tendency was towards mechanization, a healthy reaction from the over-individualized theatre of the preceding age. Only rhythm now counted, not the logos, the spoken word. In these circumstances the features might well disappear under a mask.

This wave, which lasted for about the first decade after the war, was general. The Russian

theatre encouraged it by its magnificent command of physical technique; and the tendency was everywhere manifest, without exception. The Bauhaus at Dessau, under Oskar Schlemmer, created spherical metal masks or grotesque forms which covered not merely the face, but also the whole head. There is a certain historical interest in the following description of a mask which dates from 1927: "we shall uniform and typify the 1, 2, 3 actors with padded jumpers and pasted masks, which shall simplify and unify the different parts of the body; and we shall clothe the 3 actors in the primary colours red, blue, and yellow; and we shall prescribe a special way of walking for each of these actors—slow step, normal step, tripping —and make them step out into space to the sound of the drum and gong, so as to produce what we call space-dancing." Picasso designed at that period the costumes for the ballet Parade (Cocteau and Satie) which consisted entirely of symbolic structures larger than the giant masks of primitive peoples, and representing parts of houses, megaphones, and models of cylinders and cubes, but never faces. Fernand Leger also concealed the face under the rhythmical elements of the costume. Futurism intoxicated itself with the notion of mechanical men (Prampolini, Depero); and it was finally asked in all seriousness whether man was needed on the stage at all, whether a mechanical ballet would not satisfy the desire for rhythm and for the decomposition of its participants into simple geometrical forms more accurately than any living performer. This was all the less surprising, since sculpture had already abandoned the human head in favour of a conglomeration of strict forms (fig. 235).

This excess of materialism which had overtaken the stage was explained by the old antipathy for any sort of individualism. In the desire to protest against the kind of acting which had survived from the pre-war period, stylization was carried to such lengths that form collapsed entirely. From the opposite direction, however, the strong hankering of the age after magic began to make itself felt. This took the form partly of a protest against mechanization, partly as an auxiliary and substitute in the difficult search for new forms of life. Magic, unencumbered by material considerations, seemed the best short cut to the desired end. But precisely because the mask had been seized upon as an abstraction, it suddenly and surprisingly displayed its magic powers; and in the hands of the artists who used it (in so far as they were artists) it became a new thing. We find ourselves today at this important juncture: it is a moment of absolute rebound from purely material form towards a new content.

Here too a better knowledge of the mask was necessary; the plastic arts could not recover it merely by contemplating the world of appearances (W. Hausenstein, Barbaren und Klassiker, Munich 1923; plentiful examples from exotic cultures all over the world, but not concentrated on the mask, as in the present attempt). Picasso is now producing sculpture (figs. 237, 239) which returns to a primitive intensity of facial expression, hovering between man and beast, in the greatest possible contrast to the "expressionistic" masks mentioned above. The original animal element in the mask is being brilliantly rediscovered (figs. 232, 238). It is astonishing how close the relation can be between a mask produced by the highest culture of Europe and the powerful creations of primitive man, without the

faintest superficial connexion. Compare Emil Pirchan's mask (fig. 231) with the wooden mask from Nigeria (fig. 28), and Jan Hawermann's mask (fig. 233) with the mask from the Aleutian Islands (fig. 57). The correspondence is by no means merely external, conditioned by the material. Both masks share not only the same conception of form, but also a deep community of magical content. How different are the ways by which Gordon Craig's woodcut abbreviations (figs. 240—243) and the broad and healthy sculpture of Teschner (figs. 253, 254) both seek to approach the daemonic character of the mask-face! I personally feel that the highest point of contemporary mask-sculpture is reached when the individual character of the countenance is reduced to the typical forms of the mask by means of a technical discipline learnt from Japan, as in the work of Marianne Heymann (fig. 250) or in Taschme's death-mask (fig. 248). Notice the distance from the human skull which only a great sculptor can achieve: the astonishing expressiveness of the absolutely empty eye-sockets, which yet gaze at us with a fixity beyond the reach of any living eye. The daemonic horror of a skull-mask, imprisoning the spirit of some dead man in a remote African village, speaks to us here. Contemplate too the profound expression in the masks by the same artist (figs. 244—247): what unity of form and content—it is all one whether the chosen reality is a mother's face, racked with pain, or a couple of surfaces of brass or painted wood! How completely daemonic the fairy-mask: no longer animal this—a mere fragment of gold-foil, yet all engrossed in the world's unending dream.

Poised on the mask are all the terrible experiences and fancies of mankind. Fallen heads are struck off and the humour of the brain is drunk. Beasts lord it over us. Mouths gape. Frightful eyes stare at us from every side. Since man began to shape and carve these things, he has freed himself little by little. When he laid the finishing touch to his work and invented the theatre, he mastered his own myth, instead of letting himself be mastered by it. At its height the mask stands for the plenitude of creative power, that is yet aware of the secret of its source. Here in our hand we hold one of the most effective keys into the secret realm of our own past.

NUMERICAL LIST

OF PLATES

1. Mask of a god of the Kwakiutl-Indians. Alert Bay, Vancouver Island. B. C. New York, Museum of the American Indian.
2. Mask. Kwakiutl. New York, Museum of the American Indian.
3. Mask of the "Nulmal" one of the chief characters in the Winter Ceremonies. Kwakiutl. N. W. Coast of South America.
4. Mask. Kwakiutl, Vancouver Island, B. C. New York, Museum of the American Indian.
5. Mask. Kwakiutl, Vancouver Island, B. C. New York, Museum of the American Indian.
6. Wooden Dance Rattle. Queen Charlotte Islands, Haida. London, British Museum.
7. a–c. Ceremonial Masks, Vancouver Island. London, British Museum.
8. Animal 's head (Mask) of the Kwakiutl Indians. New York, Museum of the American Indian.
9. Dance Mask (wood and skin) of the Kwakiutl Indians. Alert Bay, Vancouver Island, B. C. New York, Museum of the American Indian.
10. Dance Mask (wood, mother-of-pearl, feathers and skin) of the Kwakiutl Indians. Alert Bay, Vancouver Island, B. C. New York, Museum of the American Indian.
11–16. Mask Robes of the Cucama Indians. Material: black cloth, black indiarubber, white paper (in no. 12), vegetable and animal fragments, e. g. snout of the wart-hog (in no. 16) Nauta, upper Salamoes River, Peru. New York, Museum of the American Indian.
17. Silver Mask. Peru. New York, Museum of the American Indian.
18. Mummy Mask of gold. Chimu, Peru. New York, Museum of the American Indian.
19. Dance Mask of the Indians of S. Martin tlaxicolcingo (in the neighbourhood of Guadalajara), Mexico. Paris, Musée d'Ethnographie.
20. Clay rattle in human form. Bebedero. Guatemala. New York, Museum of the American Indian.
21. Clay fragments. Carriacon, West Indies. New York, Museum of the American Indian.
22. Clay heads, Salvador. New York, Museum of the American Indian.
23. Mask of Loolosta. The "benevolent giant". Bella Coola, British Columbia. Paris, Musée d'Ethnographie.
24a. b. Painted wooden Masks from British Columbia. Paris, Musée d'Ethnographie.
25. Ceremonial Mask of wood. Ba Telela. Belgian Congo.
26. Wooden face mask with moveable lower jaw, on the head a skull Calaber. Berlin, Museum für Völkerkunde.
27. Dance Mask of wood. Sierra Leone. Vienna, Museum für Völkerkunde.
28. Wooden Mask., Water spirit as ceremonial rites. Calabar, Nigeria. Vienna, Museum für Völkerkunde.
29. Fetish dance mask of wood, Dahomey. Vienna, Museum für Völkerkunde. Prof. Finkelstein Collection.
30. Face Mask of wood. Mussoron (Congo). Vienna, Museum für Völkerkunde.
31. Dance Mask of wood. Yoruba, South Nigeria. Vienna, Museum für Völkerkunde.
32. Pygmy Collection P. P. Schebesta (Bandaka-Congo). Vienna, Museum für Völkerkunde.
33. Dance Mask of wood. Cameroon (Babanka-Tingo). Vienna, Museum für Völkerkunde. Oldenburg-Collection.
34. Mask with a large headdress, Iniche Indians, Guatemala. New York, Museum of the American Indian.
35. Dance Mask, Mosquito Indians, Sang Sang and San Carlos, Wanks River, Nicaragua. New York. Museum of the American Indian.

88. Terracotta Heads. Athens, National Museum.
89. Terracotta Heads. Athens, National Museum.
90, 91. Death masks of gold, Mycenae. Above the so-called masks of Agamemnon and Clytemnestra. Athens, National Museum.
92—95. Statuettes of Actors, Terracotta. Athens, National Museum.
96. Comic actors. Berlin, Antiquarium.
97. Woman Dancer, Terracotta. Tanagra, Milan.
98. Tragic Mask. Rome, Museo Nazionale.
99, 100. Stone Masks. First Century A. D. Naples, Museo Nazionale.
101. Actors in relief (on the right a female mime). Rome, Museo Profano Lateranese.
102. Masks in relief. Rome, Museo Vaticano.
103. Parade Helmet of the Celtic Cavalry. England, time of the Roman occupation. London, British Museum.
104. In the middle, Helmet mask of bronze, first century A.D. On the sides, Etruscan clay masks, used in burial ceremonies. London, British Museum.
105, 106. Silver masks of Minerva. Paris, Louvre, Salle des bijoux.
107, 108. Silene. Rome, Museo Nazionale.
109. Roman panel of masks in the Dionysos Theatre in Athens. Present condition.
110. Satyr Mask, Rain water pipe, Terracotta. Italian. Milan, Museo della Scala.
111. Mask of a woman. Terracotta (oscillum). Hellenistic. Milan, Museo della Scala.
112. Capital in the transept of the Franciscan Convent, Dubrovnik (Ragusa), Dalmatia.
113. Mask of a comic ancient, Terracotta. Hellenistic. Milan, Museo della Scala.
114. Mask of ancient. Terracotta. Hellenistic. Milan, Museo della Scala.
115. Mask with double face. Terracotta. Pre-Roman. Naples. Milan, Museo della Scala.
116. Mask with double face. Hellenistic. Milan, Museo della Scala.
117. Sarcophagus. Apollo and the Muses. Rome, Museo Nazionale.
118. Mask of Dionysos, Bronze. Vienna, Kunsthistorisches Museum.
119. Scene from Terence's "Eunuchi", IV. 6, 7. Codex Vaticanus.
120. Scene from Terence's "Eunuchi", II. 2. Codex Vaticanus.
121. Satyrs. Masks for the performance in the Theatre of Syracuse. Present day.
122. S. Maria de Tahull, 12th century. Fresco. Barcelona, Museum of Catalonian Art.
123. Mosaic. St. Marks, Chapel of St. Isidore. Episode of his Life. 14th century. Venice, St. Marks.
124. Picture Bible. French, 14th century. Vienna, National library. Cod. 2554.
125. Reliquary of St. Vitus. Cologne.
126. Head of Christ. Paris, Musée de Cluny.
127. Head of John the Baptist, End of 15th century. Paris, Musée de Cluny.
128. Mask of Christ, South German. About 1570.
129—132. Stone mask capitals. Paris, Musée de Cluny.
133. Ridge Tile from the green tower in Ravensburg (Würt.) German, 14th century. Vienna, Figdor Collection.
134. Roof Tile from the Church of the Holy Cross, Swabian Gmünd. 14th century. Vienna, Figdor Collection.
135. Mask of a Faun, Marble. Unknown Italian master of the 17th century (formerly incorrectly ascribed to Michelangelo). Florence, Museo Nazionale.
136. Fool's sceptre (Marotte). French, 16th century. Vienna, Figdor collection.
137. Head of a Fool's sceptre (Marotte) French, 18th century. Vienna, Figdor collection.
138. Door knocker, French, first half of 16th century. Vienna, Figdor collection.
139. Karel van Mander. Group of Fools. Drawing. Vienna, Albertina.
140. Statuette of fool. Northern France. Vienna, Figdor collection.
141. Nutcracker, Flemish. Vienna, Auspitz collection.
142. Entrance ticket for the St. Samuel Theatre. Carnival 1758. Venice, Museo Civico Correr.
143. Carnival, masks in the Wienerwald 1933. Photograph Vienna, National Library.
144. P. Longhi: Street scene. Venice, Museo Civico Correr.
145—147. Mask head (left) and mask forms (matrices). Venetian, 18th century. Venice, Museo Civico Correr.
148. Columbine and Brighella. Capodimonte porcelain. 18th century. Milan, Museo della Scala.
149. Harlequin. Chelsea porcelain. 18th century. Milan, Museo della Scala.

150. The Doctor, Capodimonte porcelain. 18th century.
151. Harlequin. Dresden porcelain. 18th century. Milan, Museo della Scala.
152. The Doctor. Capodimonte porcelain. 18th century. Milan, Museo della Scala.
153. Punchinella. Capodimonte porcelain. 18th century. Milan, Museo della Scala.
154. Cupid with mask. Nymphenburg porcelain. 18th century. Milan, Museo della Scala.
155. Harlequin. Dresden porcelain. 18th century. Milan, Museo della Scala.
156. Comedy Scene. Capodimonte porcelain. 18th century. Milan, Museo della Scala.
157. Comedy Scene. Capodimonte porcelain. 18th century. Milan, Museo della Scala.
158a–c. Brighella, Pantaloon, Harlequin. Venetian statuettes in coloured terracotta. 18th century. Milan, Museo della Scala.
159. Harlequin. Statue in polychrome terracotta. Detail from illustration 158, c. Milan, Museo della Scala.
160. Harlequin. Marionette of wood and cloth. Venetian. 18th century. Milan, Museo della Scala.
161. Brighella. Polychrome terracotta statue. Venetian. 18th century. Detail from illustration 158, a. Milan, Museo della Scala.
162, 163. Dolls' Theatre. Venetian. 18th century. Venice, Museo Civico Correr.
164. Cornelis Duyster: Carnival Jesters. Painting. Berlin, Friedrichs Museum.
165. Sebastian Vrancx: Carnival. Cologne, Wallraf-Richartz-Museum.
166. Tiepolo: Punchinello, Drawing. Venice, Exhibition of the 18th century. Rome, private ownership.
167. Impromptu Comedians. Drawing. Paris, Louvre.
168–175. Italian Mask Carnival. "Ove si Veggono in Figure Varie Inventione di Capritii" (1642). Munich, Theatermuseum.
176, 177. Masks of the Roman Carnival (above, Punchinellos). F. Valentini, "Abhandlung über die Komödie aus dem Stegreif". Berlin 1826. Vienna, National-Library.
178, 179. Gaspar Lavater: "L'Art de connaître les hommes par la Physionomie". Volume IX. Paris 1807. 24 heads, presumably the change of a Frog Mask into the Mask of Apollo through the alteration of the lines of the face. Copper engraving. Vienna, National Library.
180. Animal mask. Salzburg, Städtisches Museum.
181. Devil Mask. Salzburg, Städtisches Museum.
182. Devil Mask of Kiefersfelden (Dr. Hans Moser, Munich).
183. Wooden Mask of demons, Ceylon. Vienna, Museum für Völkerkunde.
184. Dance Mask, Ceylon, Vienna, Museum für Völkerkunde.
185. King's mask of Wood, Ceylon. Vienna, Museum für Völkerkunde.
186. Face of a demon with moveable lower jaw, worn to prevent chills, Ceylon. Vienna, Museum für Völkerkunde.
187. Theatre mask of paper-mâché, Burma. Vienna, Museum für Völkerkunde.
188. Paper-mâché mask, Burma. Vienna, Museum für Völkerkunde.
189. Demon mask of wood (Rakschasa Masks), Java. Vienna, Museum für Völkerkunde.
190. Demon mask of wood (Rakschasa Masks), Java. Vienna, Museum für Völkerkunde.
191. Miniature masks, Java. Leyden, Rijks Ethnographisch Museum.
192. Mask of a Singhalese devil-dancer. "Gurul sayage" (King of the birds). Stettin, Museum für Kunstgewerbe.
193. Wooden mask, inlaid with metal. "Guru". Sumatra. Vienna, Museum für Völkerkunde.
194. Coloured wooden relief from Bali. Leyden, Rijks Ethnographisch Museum.
195. Mask of the Demon Prince Rāvana, made of paper-mâché, gilded, painted and set out with bits of looking-glass. (Lakon Mask). Siam. Berlin, Museum für Völkerkunde. Riebeck Collection.
196. Mask. "Ling" (Ape), Siam. Berlin, Museum für Völkerkunde. Lessler Collection.
197. Mask. "Yksa" (Demon). Siam. Berlin, Museum für Völkerkunde. Lessler Collection.
198. A soldier. (Lakon Mask), Siam. Berlin, Museum für Völkerkunde, Riebeck Collection.
199. Medicine Mask, Siam. Berlin, Museum für Völkerkunde.
200–202. Theatre masks made of paper, Siam. Berlin, Museum für Völkerkunde.
203. Paper-mâché mask. China. Leyden, Rijks Ethnographisch Museum.
204. Paper-mâché mask. China. Leyden, Rijks Ethnographisch Museum.
205. Paper-mâché theatre mask. China. Vienna, Museum für Völkerkunde.
206. Miniature Mask. China. Bronze.

207. Paper-mâché theatre mask. China. Vienna, Museum für Völkerkunde.

208–211. Tscheng Jen-Tsio. Beauty masks of the Chinese theatre, Contemporary. Vienna, National Library.

212a–d. Four leaves from a pattern book of beauty Masks. Japan.

213, 214. Two plates from L. Schneider, "Die Kunst, sich zu schminken", Berlin 1831. Vienna, National Library.

215. Jase onna (thin woman) Japan.

216. Ko-jischi-Mask.

217. Japanese Mask. Berlin, Museum für Völkerkunde.

218. Hannya-Mask.

219. Sanko Mask, Japan. Berlin, Museum für Völkerkunde.

220. Uba Mask (elderly woman), Japan. Berlin, Museum für Völkerkunde.

221. Fox mask (Kitsune), Kyogen. Berlin, Museum für Völkerkunde.

222. A Japanese Theatre Mask, Shinja.

223. Japanese wooden mask, Kijo. Vienna, Museum für Völkerkunde. Weltreisesammlung Ferdinand Este.

224. Figures of Demons and Gods, Japan.

225. Paper-mâché horse mask, Japan. Vienna, Museum für Völkerkunde.

226. Head of a sign-post, in wood, Korea. Vienna, Museum für Völkerkunde.

227. Wooden dance mask, Tibet. Vienna, Museum für Völkerkunde. Weltreisesammlung Ferdinand Este.

228. Wooden dance mask, Tibet. Vienna, Museum für Völkerkunde. Weltreisesammlung Ferdinand Este.

229. Three-eyed Demon Mask, Tibet. Leyden, Rijks Ethnographisch Museum.

230. Demon mask, Tibet. Leyden, Rijks Ethnographisch Museum.

231. Emil Pirchan: Theatre Mask. Cologne, Theatre Museum.

232. Emil Pirchan: Theatre Mask. Cologne, Theatre Museum.

233. Jan Hawermann: Mask for Stravinsky's "L'Histoire d'un Soldat".

234. Herbert Keller: Mask. Cologne, Theatre Museum.

235. Rudolf Belling: Sculpture. 1923.

236. Georg Grosz: Construction. 22. Vienna, National Library.

237. Pablo Picasso: Sculpture.

238. Michael Larionow: Bird Mask.

239. Pablo Picasso: Sculpture.

240–243. Edward Gordon Craig: Masks. Woodcuts. Vienna, National Library.

244–247. Taschme: Above: Mask of Mothers. Below, left: Mask made of brass and painted wood; right: Fairy Mask, gilded.

248. Taschme: Death Mask.

249–252. Marianne Heymann. Masks. Above, left: Tunisian woman; right: a Girl. Below, left: Old peasant (Death Dance); right: Sick child.

253. Richard Teschner: Dance Mask. Electra.

254. Richard Teschner: Dance Mask. Electra.

255. Sculpture, Arabella, "The romance of a Horse" (Westi Film). Vienna, National-Library, Film-Section.

PLATES

PLATE 1

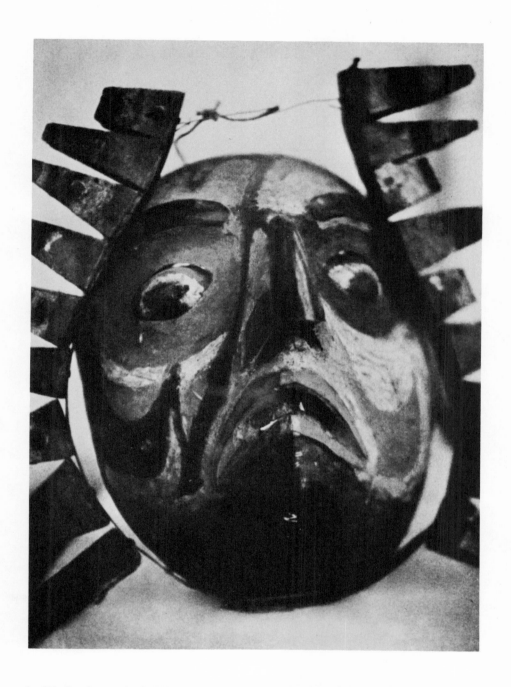

1. Mask of a god of the Kwakiutl-Indians. Alert Bay, Vancouver Island, B. C.
New York, Museum of the American Indian.

PLATE 2

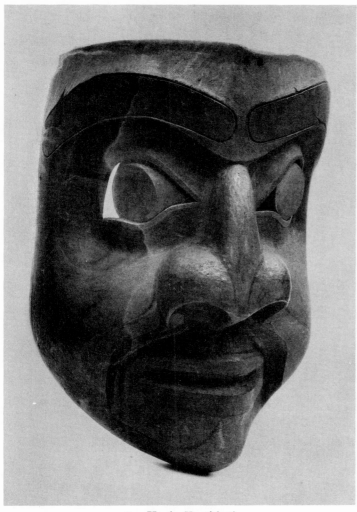

2. Mask. Kwakiutl.
New York, Museum of the American Indian.

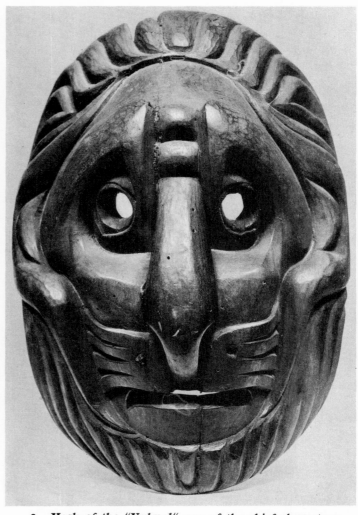

3. Mask of the "Nulmal" one of the chief characters
in the Winter Ceremonies. Kwakiutl.
N. W. Coast of South America

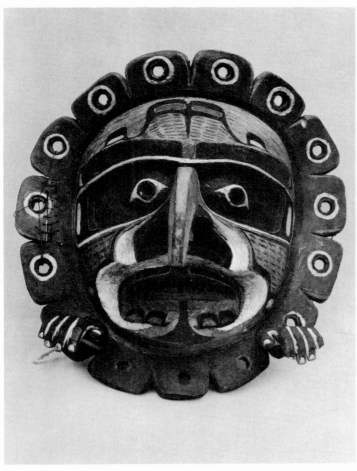

4. Mask. Kwakiutl, Vancouver Island, B. C.
New York, Museum of the American Indian.

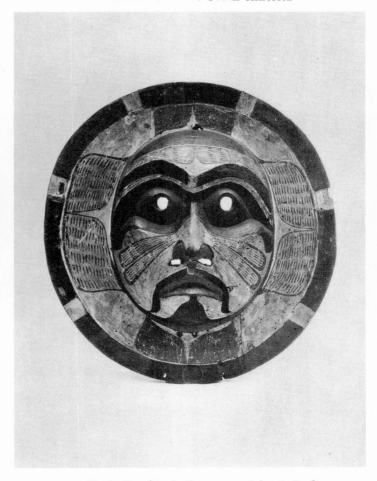

5. Mask. Kwakiutl, Vancouver Island, B. C.
New York, Museum of the American Indian.

PLATE 3

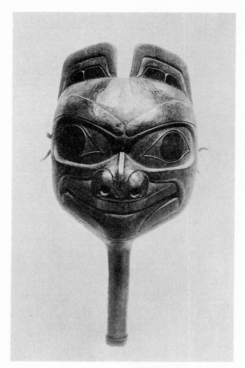

6. Wooden Dance Rattle. Queen Charlotte Islands, Haida.
London, British Museum.

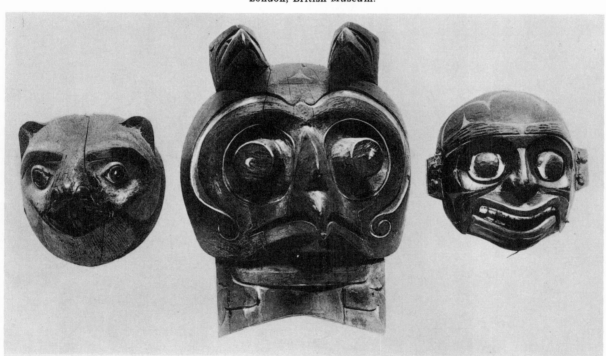

7. a—c. Ceremonial Masks, Vancouver Island.
London, British Museum

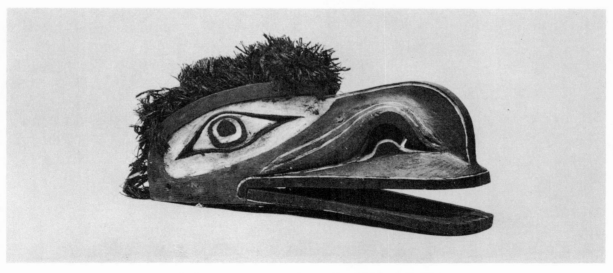

8. Animal's head (Mask) of the Kwakiutl Indians.
New York, Museum of the American Indian.

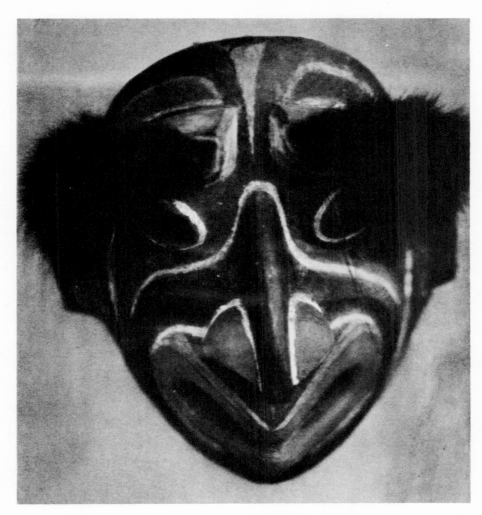

9. Dance Mask (wood and skin) of the Kwakiutl-Indians. Alert Bay, Vancouver
Island, B. C.
New York, Museum of the American Indian.

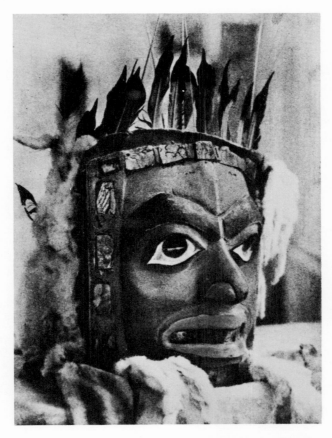

10. Dance Mask (wood, mother-of-pearl, feathers and skin) of the
Kwakiutl-Indians. Alert Bay, Vancouver Island, B. C.
New York, Museum of the American Indian.

PLATE 5

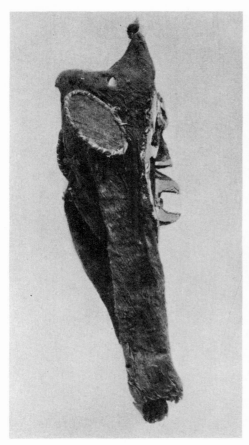
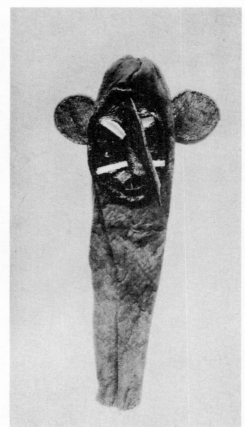
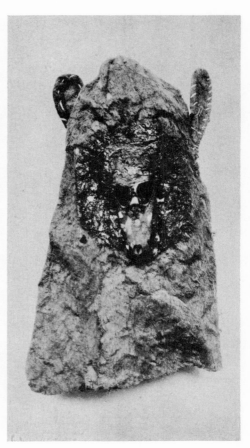
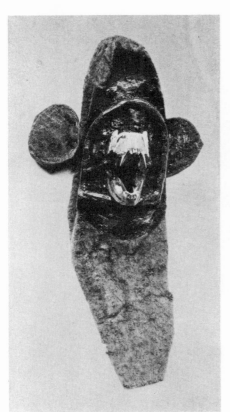
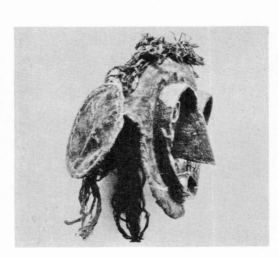
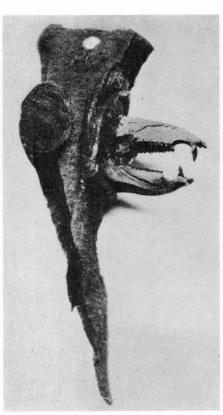

11—16. **Mask Robes of the Cucama Indians.**
Material: black cloth, black indiarubber, white
paper (in no. 12), vegetable and animal fragments,
e. g. snout of the wart-hog (in no 16) Nauta,
upper Salomoes River, Peru.
New York, Museum of the American Indian.

PLATE 6

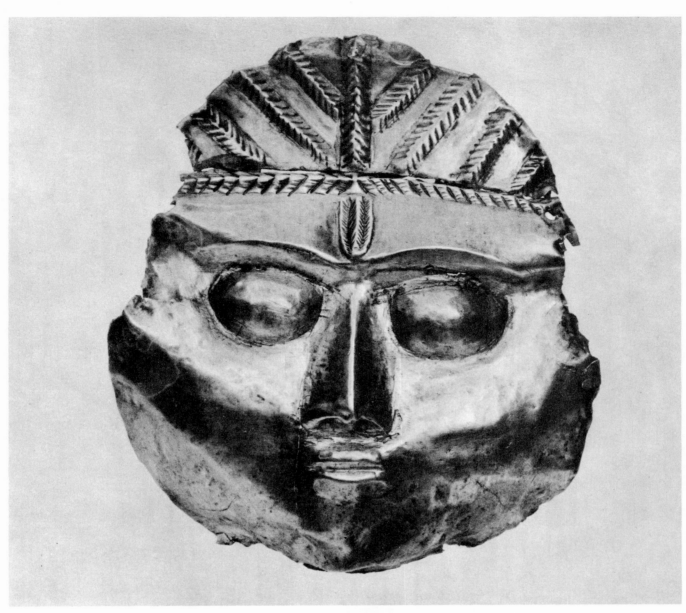

17. Silver Mask. Peru.
New York, Museum of the American Indian.

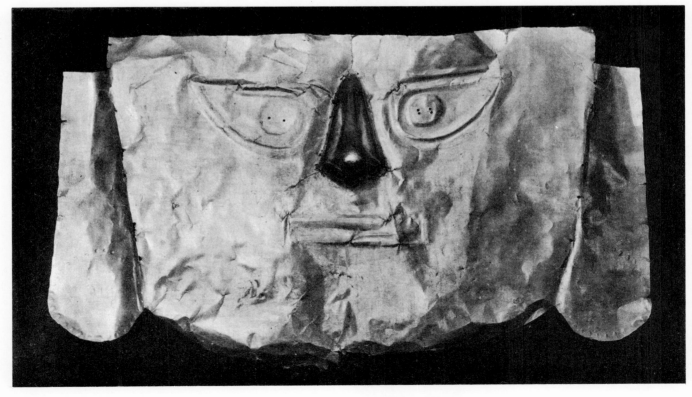

18. Mummy Mask of gold. Chimu, Peru.
New York, Museum of the American Indian.

PLATE 7

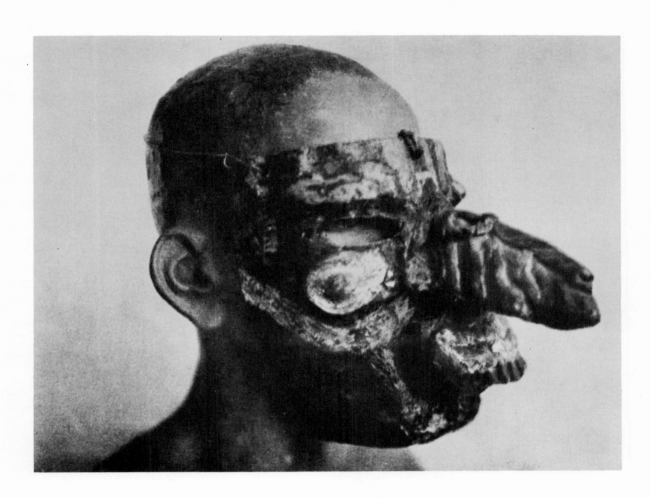

19. Dance Mask of the Indians of S. Martin tlaxicolcingo (in the neighbourhood of Guadalajara), Mexico.
Paris, Musée d'Ethnographie.

PLATE 8

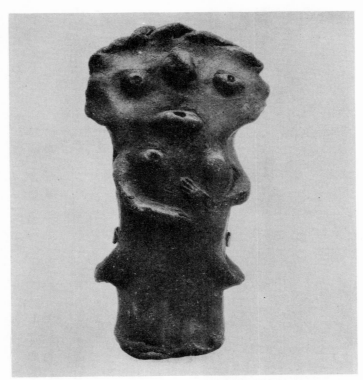

20. Clay rattle in human form. Bebedero. Guatemala.
New York, Museum of the American Indian.

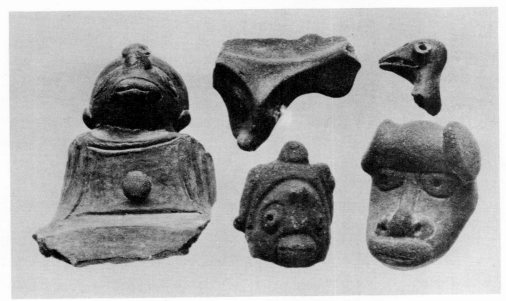

21. Clay fragments. Carriacon, West Indies.
New York, Museum of the American Indian.

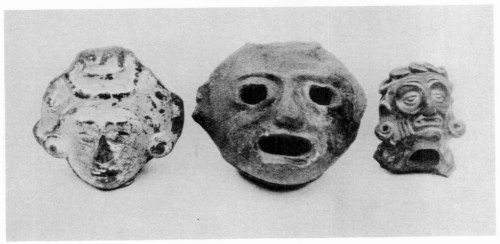

22. Clay heads. Salvador.
New York, Museum of the American Indian.

PLATE 9

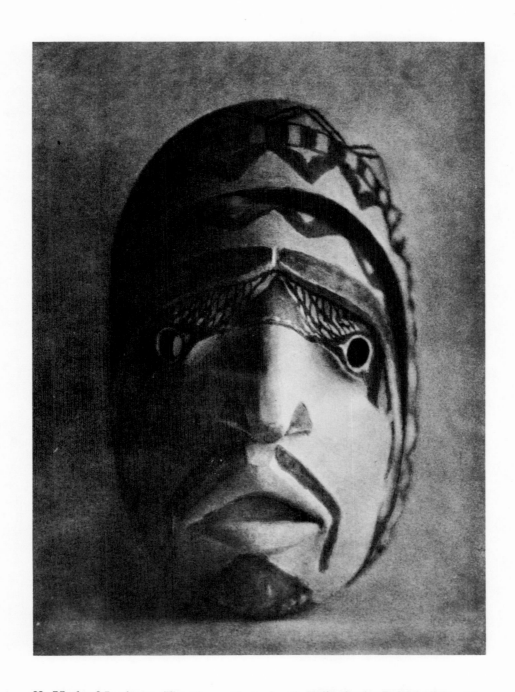

23. Mask of Loolosta. The "benevolent giant". Bella Coola, British Columbia.
Paris, Musée d'Ethnographie.

PLATE 10

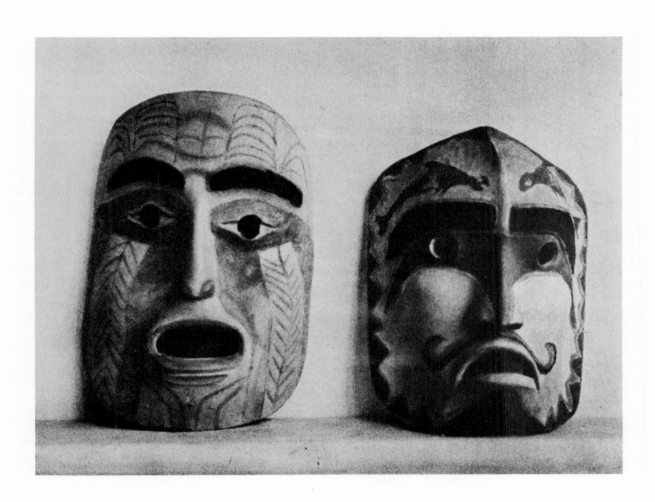

24 a, b. Painted wooden Masks from British Columbia.
Paris, Musée d'Ethnographie.

PLATE 11

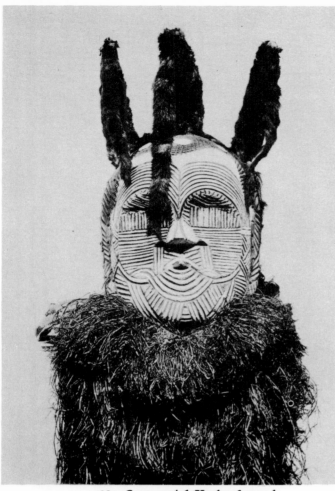

25. Ceremonial Mask of wood.
Ba Telela. Belgian Congo.

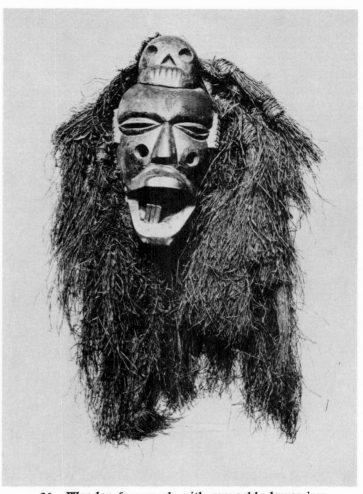

26. Wooden face mask with moveable lower jaw,
on the head a skull, Calabar.
Berlin, Museum für Völkerkunde.

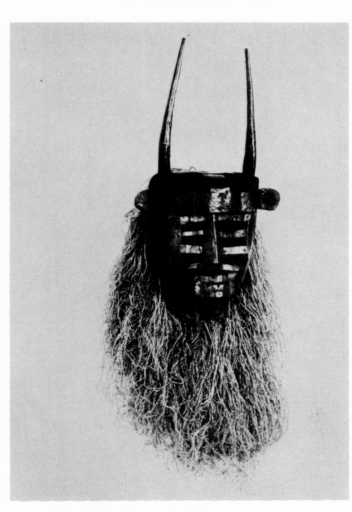

27. Dance Mask of wood. Sierra Leone.
Vienna, Museum für Völkerkunde.

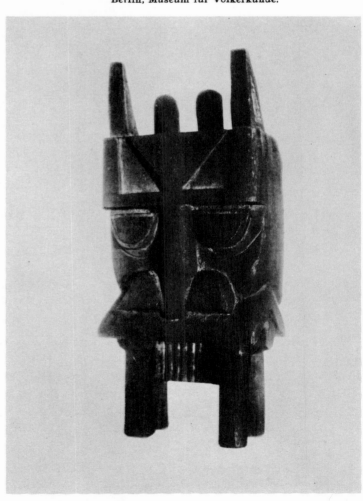

28. Wooden Mask. Water spirit at ceremonial rites.
Calabar, Nigeria.
Vienna, Museum für Völkerkunde.

PLATE 12

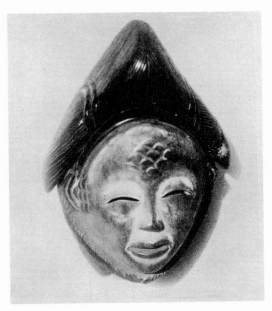

29. **Fetish dance mask of wood, Dahomey.**
Vienna. Museum für Völkerkunde.
Prof. Finkelstein Collection.

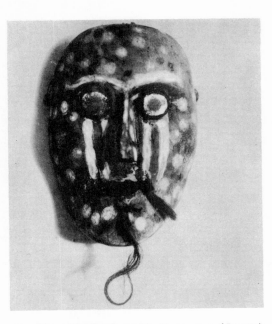

30. **Face Mask of wood. Mussoron (Congo).**
Vienna, Museum für Völkerkunde.

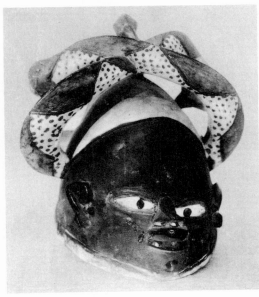

31. **Dance Mask of wood. Yoruba, South Nigeria.**
Vienna, Museum für Völkerkunde.

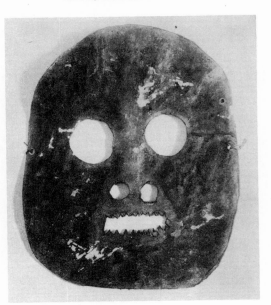

32. **Pygmy Collection P. P. Schebesta (Bandaka-Congo).**
Vienna, Museum für Völkerkunde.

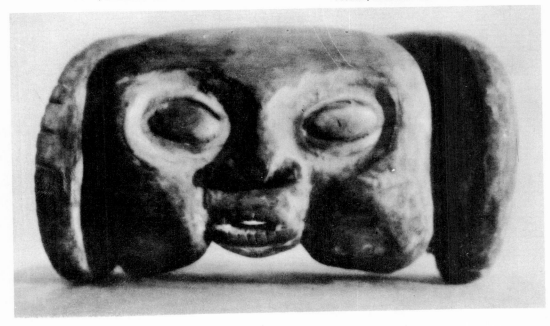

33. **Dance Mask of wood. Cameroon (Babanka-Tingo).**
Vienna, Museum für Völkerkunde.
Oldenburg Collection.

PLATE 13

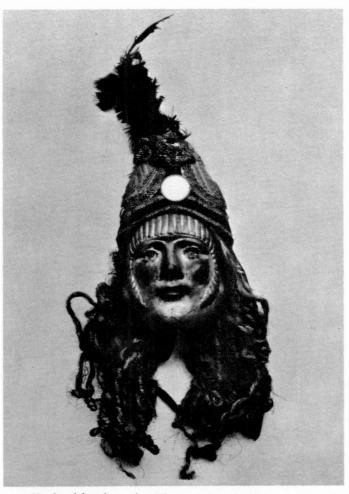

34. Mask with a large headdress, Iniche Indians, Guatemala.
New York, Museum of the American Indian.

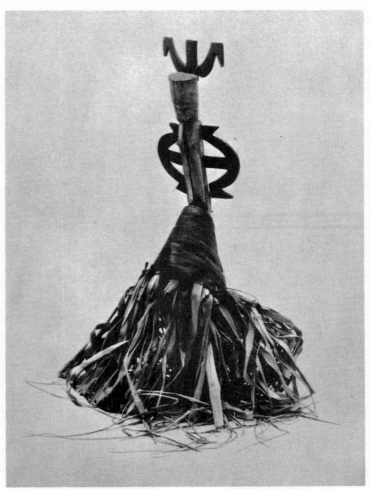

35. Dance Mask, Mosquito Indians. Sang Sang and San
Carlos, Wanks River, Nicaragua.
New York, Museum of the American Indian.

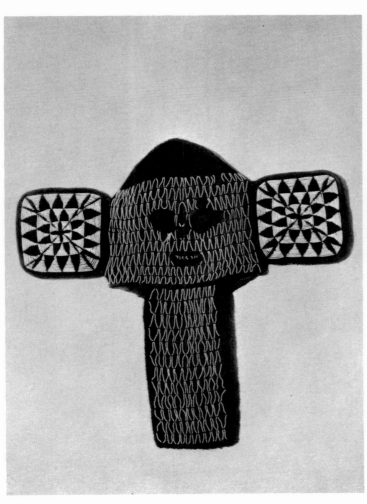

36. Cloth Mask embroidered with pearls, Cameroon.
Vienna, Museum für Völkerkunde,
Hans Mayer Collection.

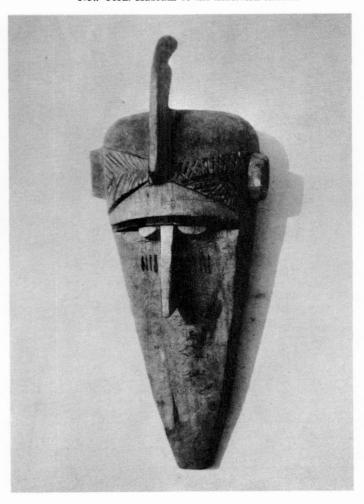

37. Wooden dance mask, Sierra Leone.
Vienna, Museum für Völkerkunde.

PLATE 14

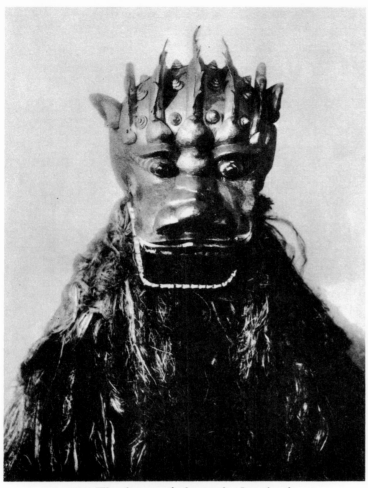

38. Wooden mask from the Laoslands.
Vienna, Museum für Völkerkunde.

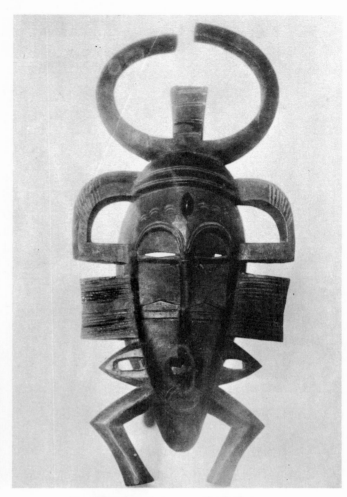

39. Wooden dance mask. Sudan.
Vienna, Museum für Völkerkunde.
Frobenius Collection.

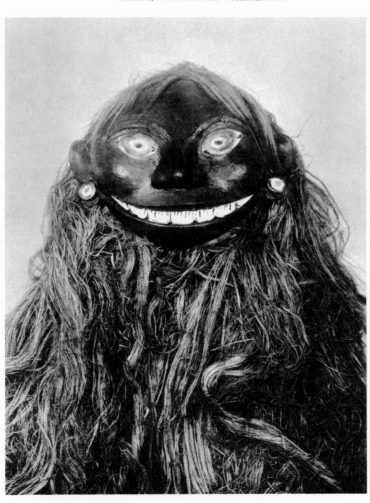

40. Ceremonial mask of bast. Used in raids for girls.
Nias.
Vienna, Museum für Völkerkunde.

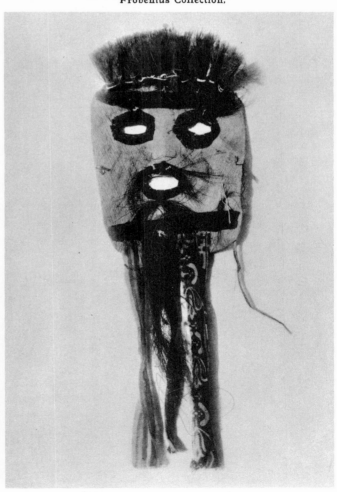

41. Wooden ancestor-mask. Laoslands.
Vienna, Museum für Völkerkunde.

PLATE 15

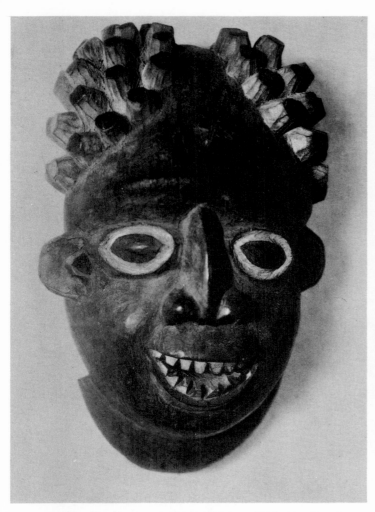

42. Wooden dance mask. Cameroon (Bafu-Fondony).
Vienna, Museum für Völkerkunde.
Hans Mayer Collection.

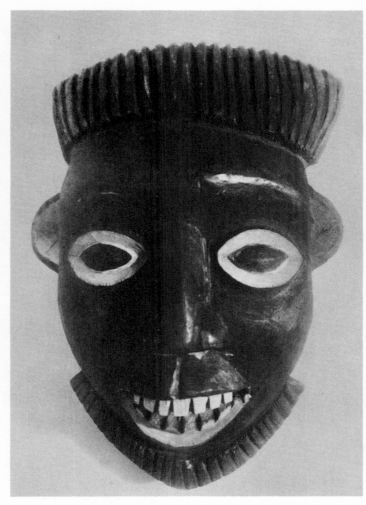

43. Mask, Cameroon.
Vienna, Museum für Völkerkunde.
Oldenburg Collection.

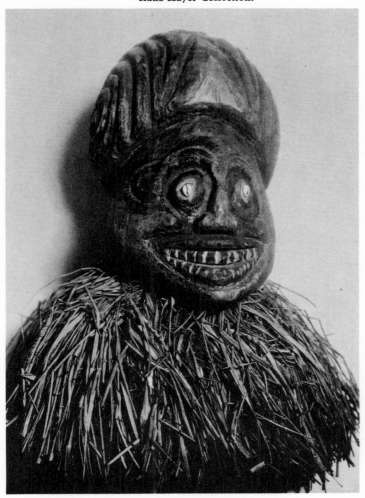

44. Wooden dance mask. Cameroon. (Tikar).
Vienna, Museum für Völkerkunde.
Oldenburg Collection.

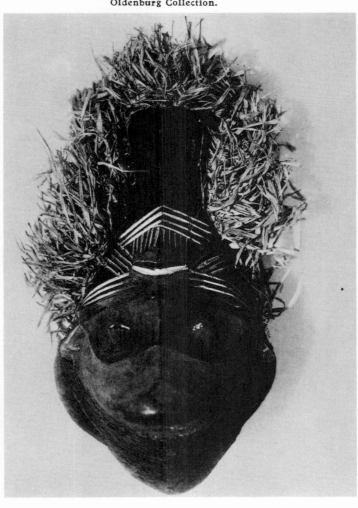

45. Wooden ceremonial mask. Congo (Mussoron).
Vienna, Museum für Völkerkunde.

PLATE 16

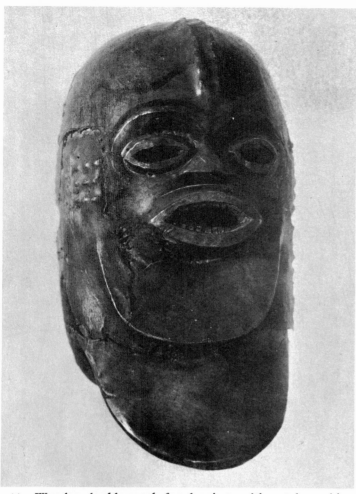

46. Wooden double mask for dancing, with antelope skin.
stretched over it. Nigeria.
Vienna. Museum für Völkerkunde.

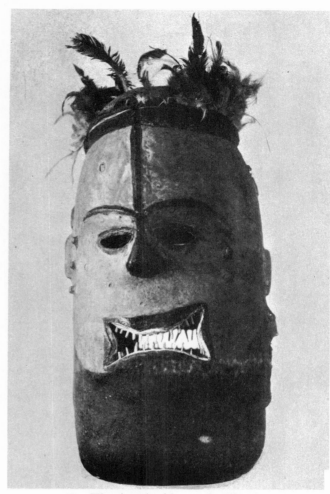

47. Wooden double mask, Nigeria.
Vienna. Museum für Völkerkunde.
Hans Mayer Collection.

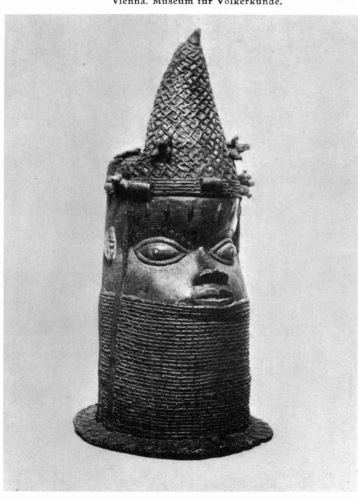

48. Metal Mask, Benin.
Leyden, Rijks Ethnographish Museum.

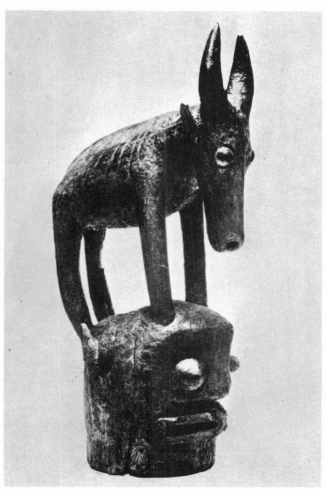

49. Wooden ceremonial mask, Nigeria.
London, British Museum,

PLATE 17

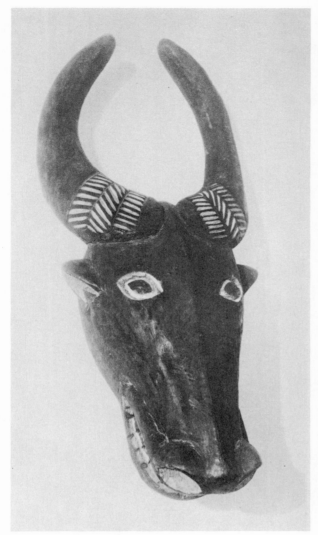

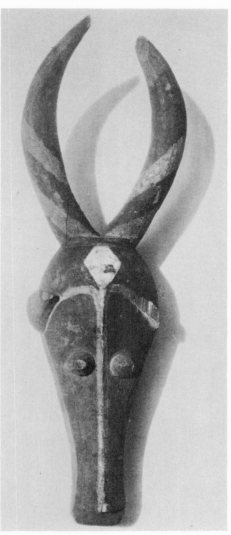

50. Wooden animal mask, Cameroon.
Vienna, Museum für Völkerkunde.
Oldenburg Collection

51. Wooden antelope face carried
in the Lacrobundi Dance, Ashantiland.
Vienna, Museum für Völkerkunde.

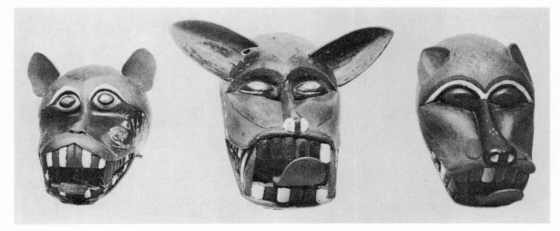

52. Animal Mask, Borneo.
Leyden. Rijks Ethnographisch Museum

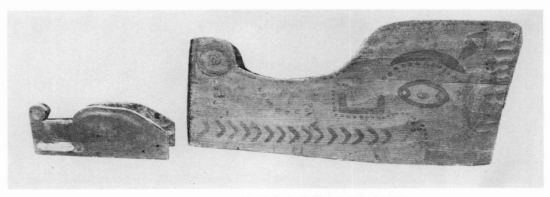

53. Mask of a wolf, Makah Indians, Washington.
New York, Museum of the American Indian.

PLATE 18

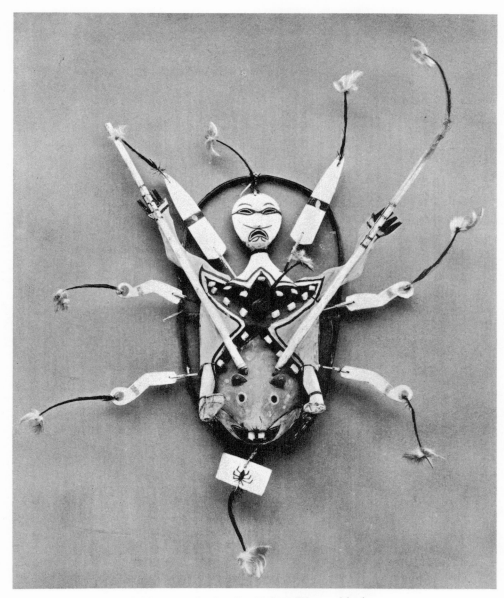

54. Eskimo Mask. Anvik, Yukon River, Alaska.
New York, Museum of the American Indian.

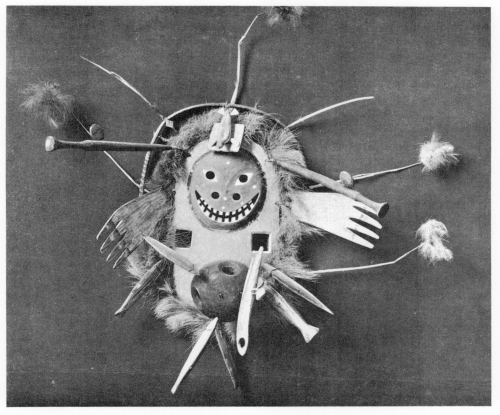

55. Shamanen-Dance mask, (Koskoquin).
Berlin, Museum für Völkerkunde.

PLATE 19

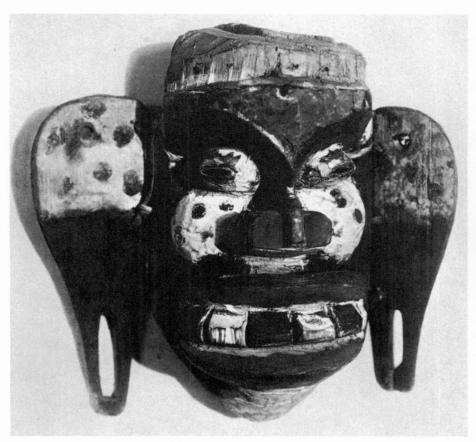

56. Wooden mask from Borneo.
Vienna, Museum für Völkerkunde,
Dr. Ballner Collection

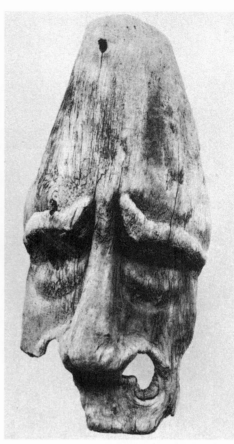

57. Wooden mask larger than life.
Aleutian Islands.

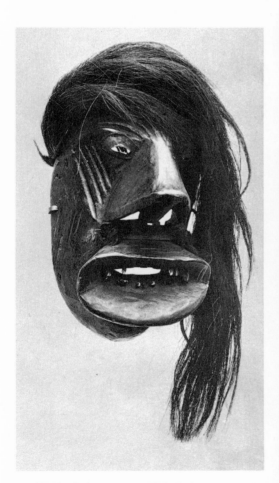

58. Mask. Grand River Reservation, Canada.
New York, Museum of the American Indian.

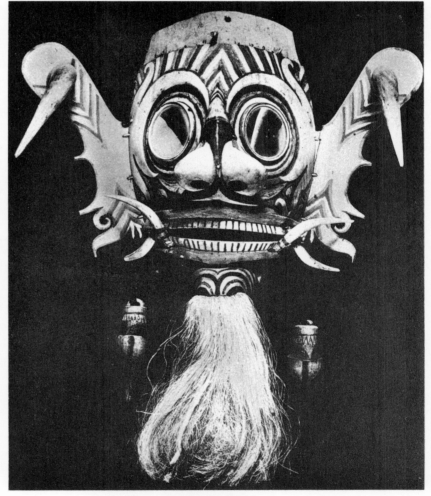

59. Dance mask, Borneo.
Leyden, Rijks Ethnographisch Museum

PLATE 20

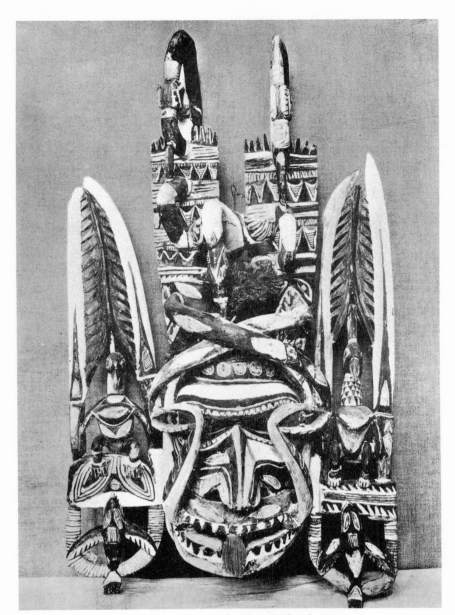

60. Dance mask, New Ireland.
Berlin. Museum für Völkerkunde.

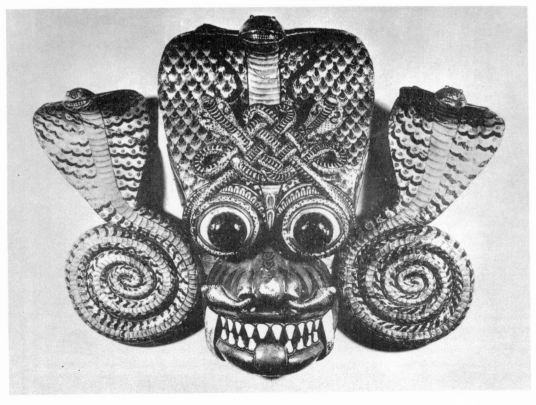

61. Mask for devil dances, Singhalese.
London. British Museum.

PLATE 21

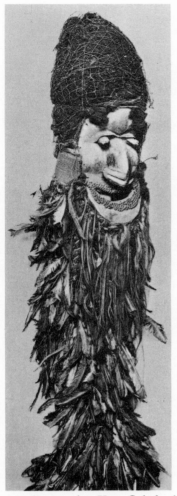

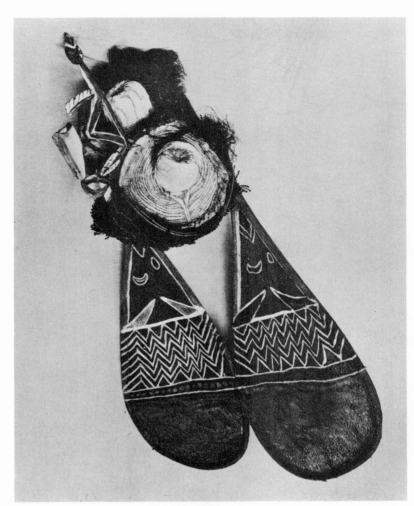

62. **Mask robe, New Caledonia.**
Berlin, Museum für Völkerkunde.

63. **Dance mask, New Pomerania.**
Berlin, Museum für Völkerkunde.

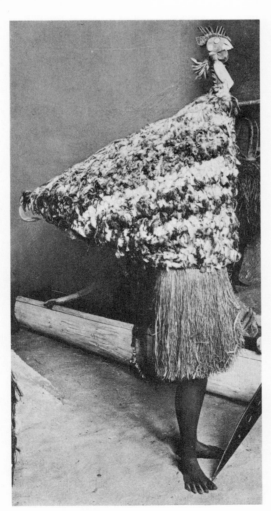

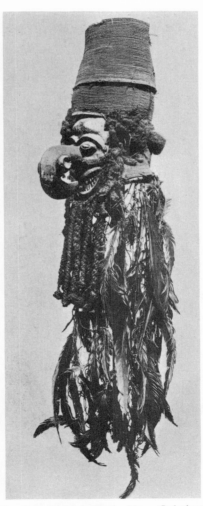

64. **Dancer, New Pomerania.**
Berlin, Museum für Völkerkunde.

65. **Ceremonial Mask. New Caledonia.**
London, British Museum.

PLATE 22

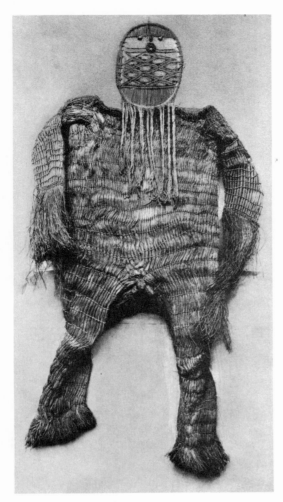

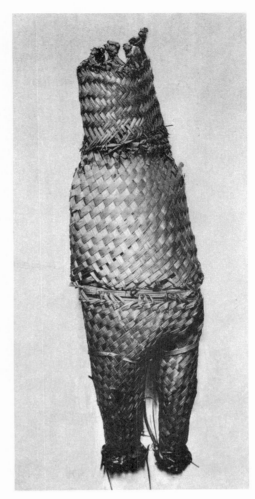

66. Oval Dance Mask. Trumai Dance Robe.
Bakairi, Xingu territory Brazil.
Berlin, Museum für Völkerkunde.
Steinen Collection.

67. Mask Robe, Caraja.
Berlin, Museum für Völkerkunde.
Ehrenreich Collection.

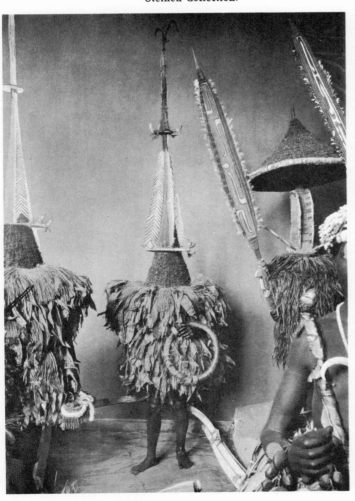

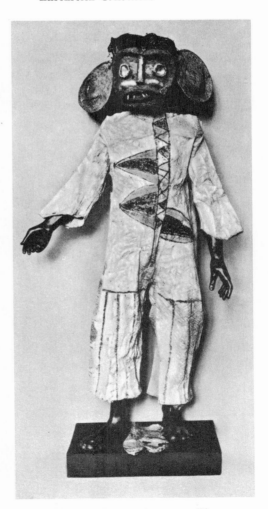

68. Mask Dances, New Pomerania.
Berlin, Museum für Völkerkunde.

69. Dancer, Upper Amazon. Ticuna.
Berlin, Museum für Völkerkunde.
Staudinger Collection

PLATE 23

70. O'Szöny (Brigetio), Roman Provincial,
about 100 A. D.
Vienna, Naturhistorisches Museum.

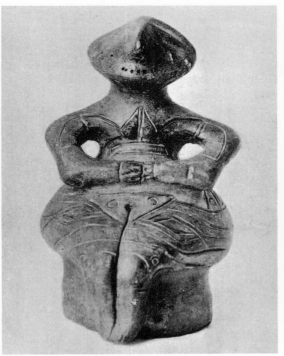

71. Thrace, neolithic, about 2000 B. C.
Vienna, Naturhistorisches Museum

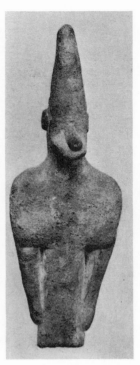

72. Zypern, marble.
2nd century B. C.
Vienna, Naturhistorisches
Museum.

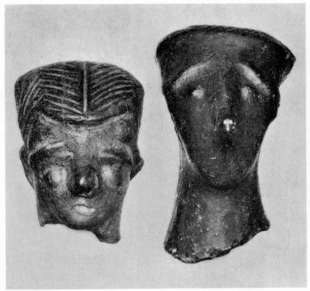

73. Butmir, Slavonia, neolithic, about 2000 B. C.
Vienna. Naturhistorisches Museum.

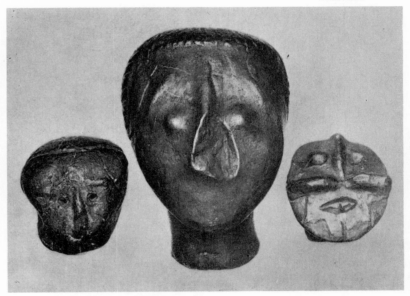

74. Butmir, Slavonia, neolithic, about 2000 B. C.
Vienna, Naturhistorisches Museum.

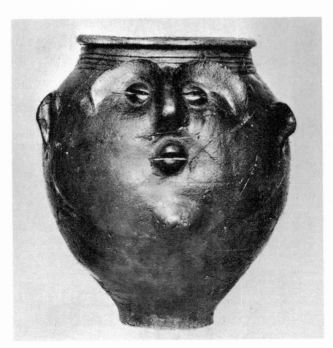

75. O' Szöny (Brigetio), Provincial Roman, 2nd century A. D.
Vienna, Naturhistorisches Museum.

PLATE 24

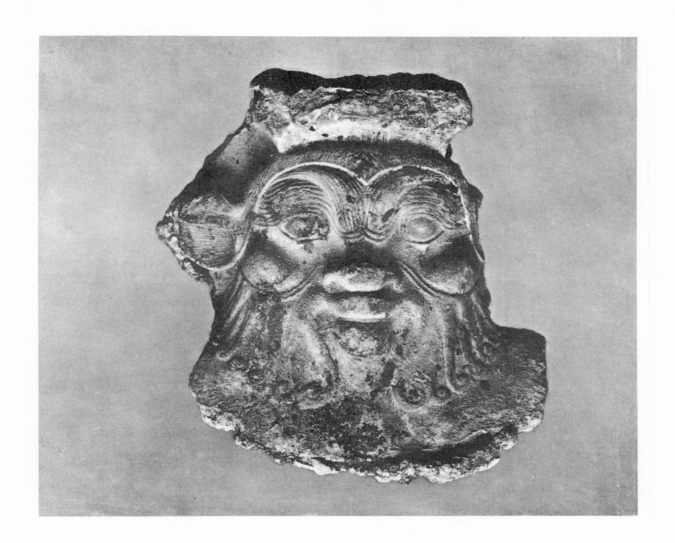

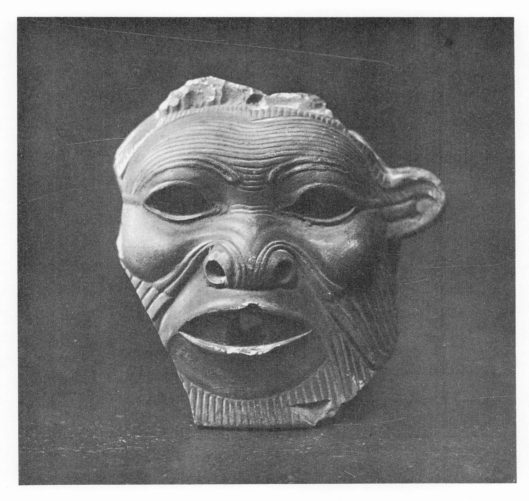

76, 77. Mask of the god Bes. Egypt.
Berlin, Aegyptisches Museum.

PLATE 25

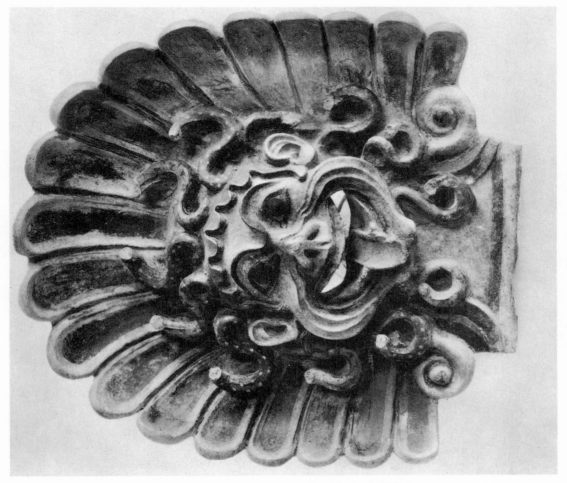

80. Winged Gorgon Head. 6th to 5th century B. C.
Rome, Villa Giulia.

79 Gorgon. Terracotta.
Athens, National Museum.

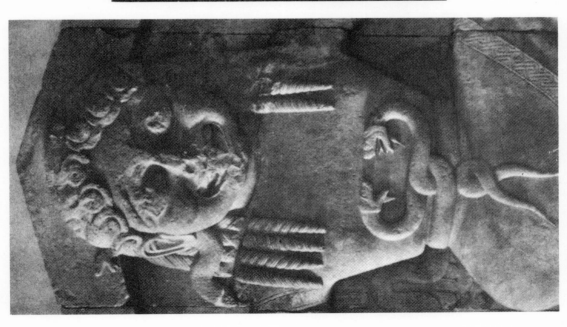

78. Middle panel from gable of temple in Corfu.
Corfu, Museum.

PLATE 26

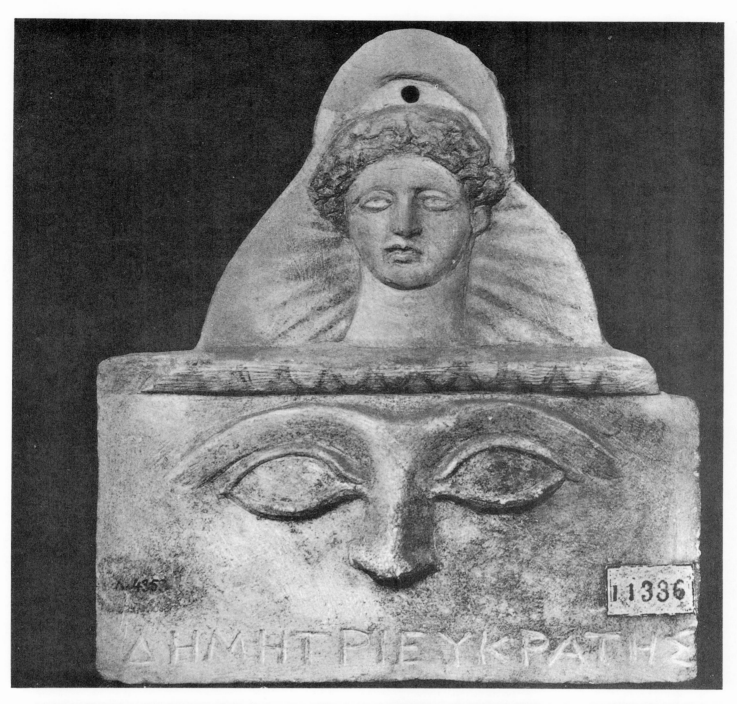

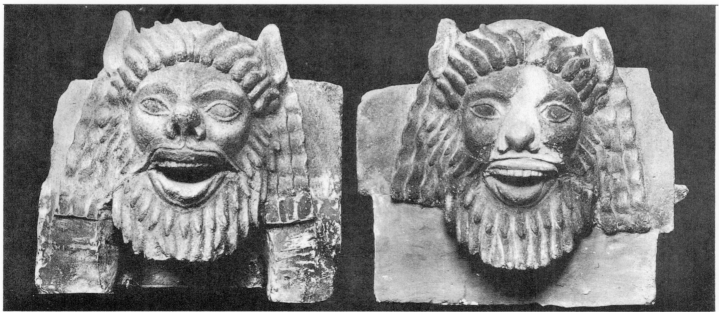

81, 82. Tiles with plastic ornament.
Athens, National Museum.

PLATE 27

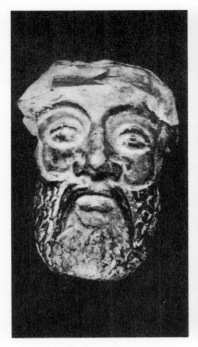

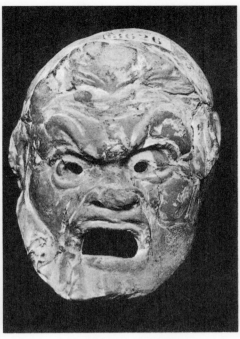

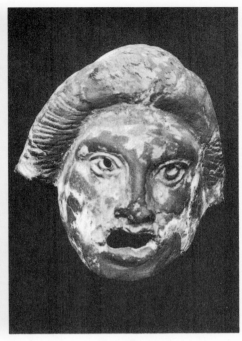

83. **Mask, Terracotta.**
Athens, National Museum.

84. **Mask, Terracotta.**
Athens, National Museum.

85. **Mask Terracotta.**
Athens, National Museum.

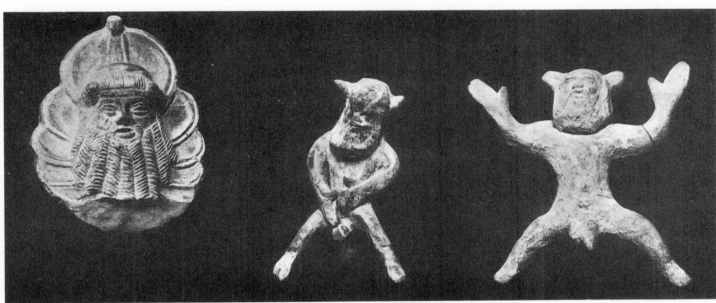

86. **Dionysos Mask.**
Athens, National Museum.

87. **Grotesque Figures.**
Athens, National Museum.

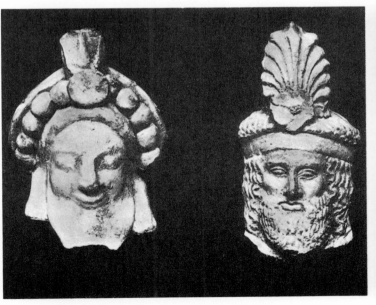

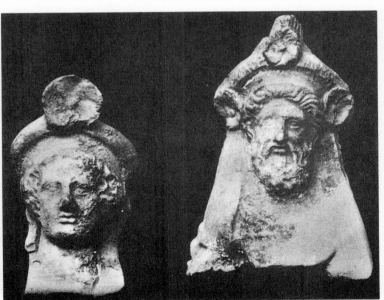

88. **Terracotta Heads.**
Athens, National Museum.

89. **Terracotta Heads.**
Athens, National Museum.

PLATE 28

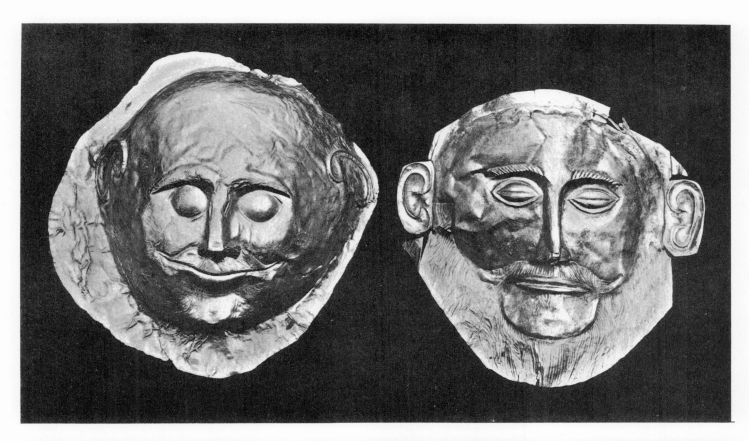

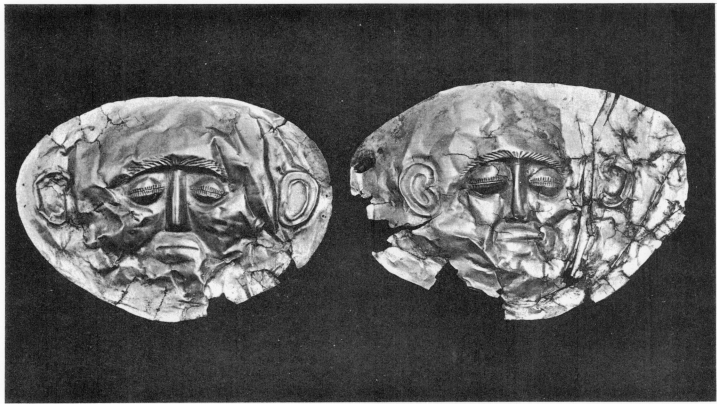

90, 91. Death masks of gold. Mycenae. Above the so-called
masks of Agamemnon and Clytemnestra.
Athens, National Museum.

PLATE 29

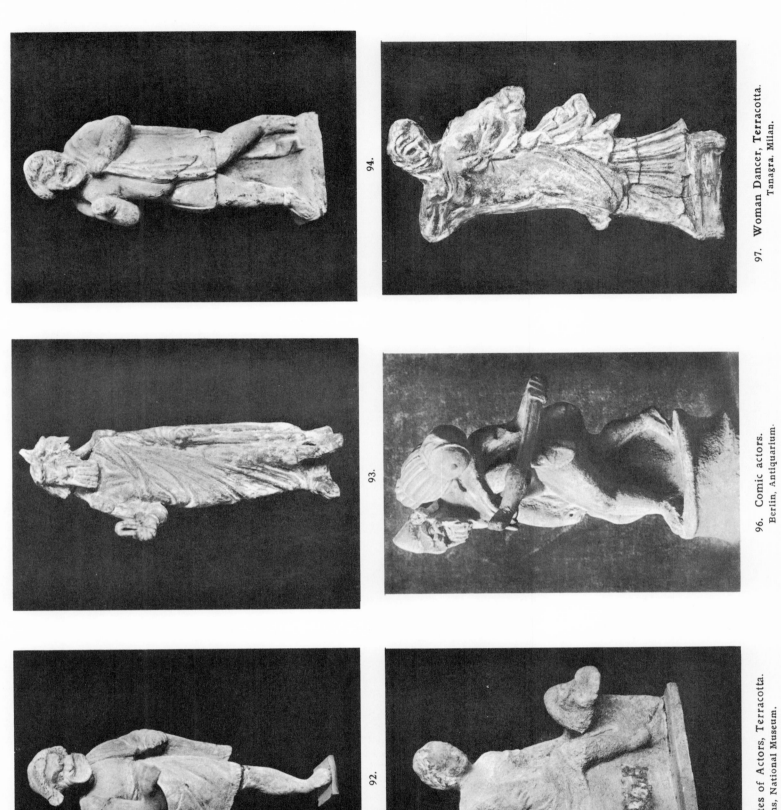

94.

97. **Woman Dancer, Terracotta.**
Tanagra. Milan.

93.

96. **Comic actors.**
Berlin, Antiquarium.

92.

92—95. **Statuettes of Actors, Terracotta.**
Athens, National Museum.

PLATE 30

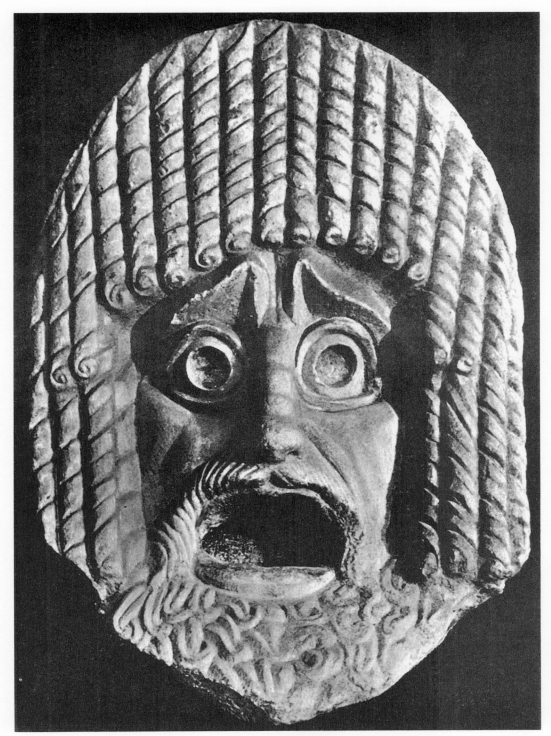

98. Tragic Mask.
Rome, Museo Nazionale.

 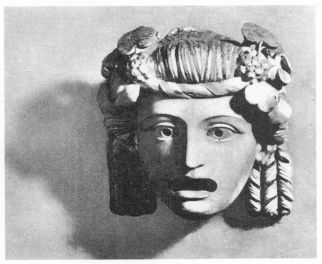

99, 100. Stone Masks. First Century A. D.
Naples, Museo Nazionale.

PLATE 31

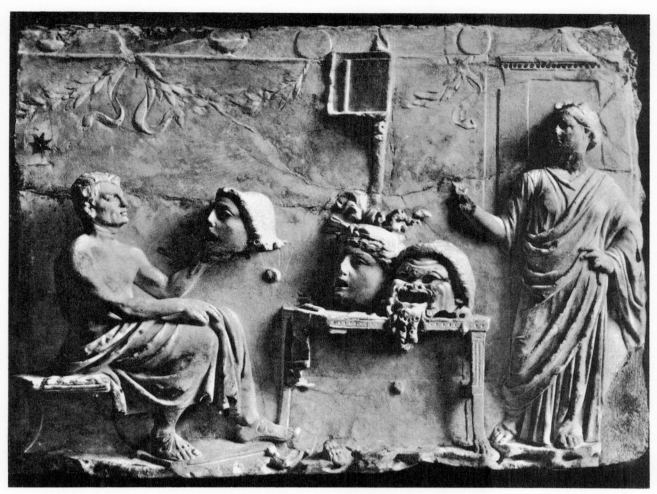

101. Actors in relief (on the right, Mimin).
Rome, Museo Profano Laternese.

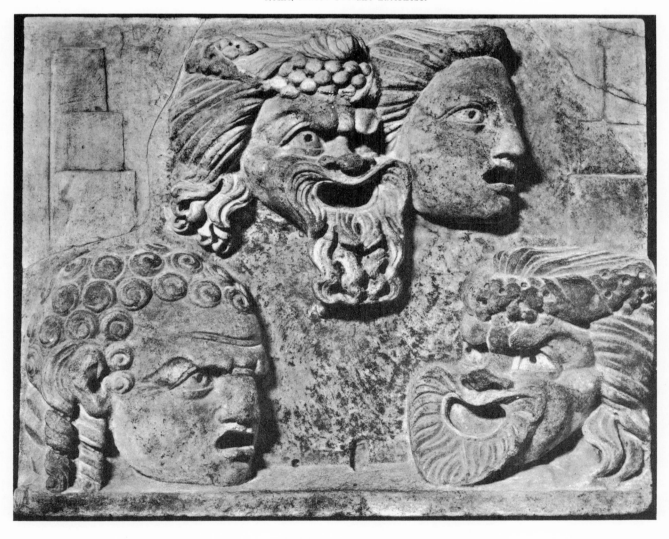

102. Masks in relief.
Rome, Museo Vaticano.

PLATE 32

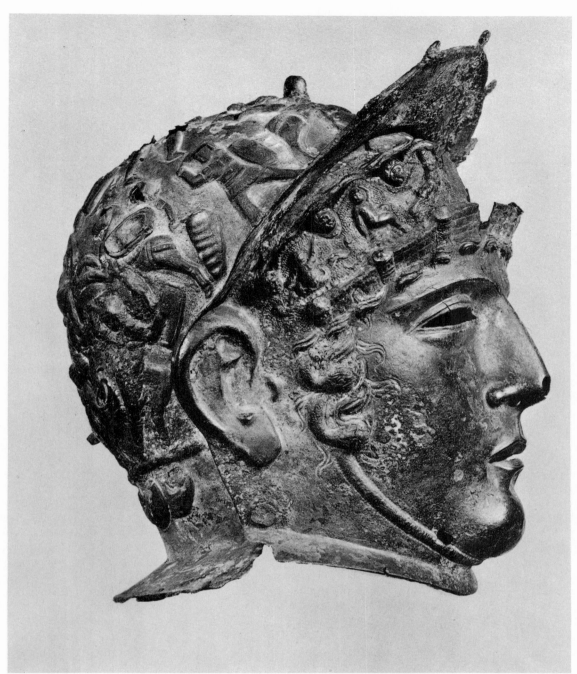

103. Parade helmet of the Celtic Cavalry. England,
time of the Roman occupation.
London, British Museum.

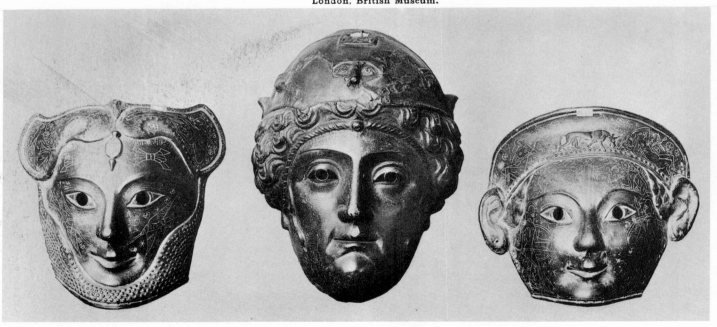

104. In the middle, Helmet mask of bronze.
1st century A. D. On the sides, Etruscan dance masks,
used in burial ceremonies.
London, British Museum.

PLATE 33

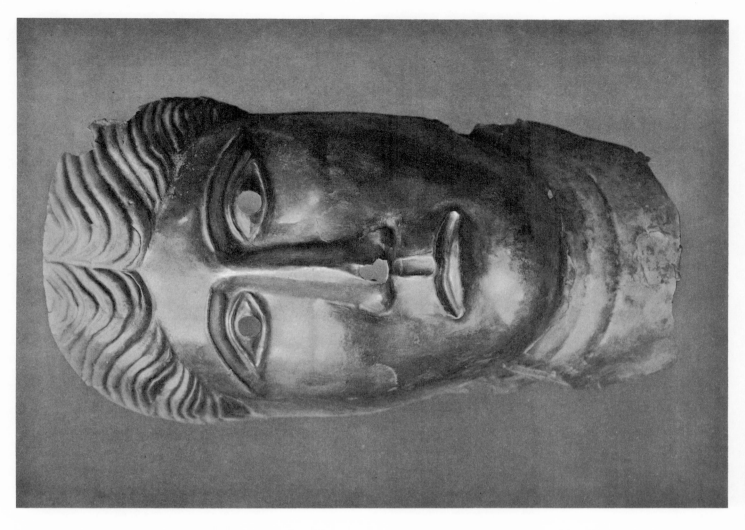

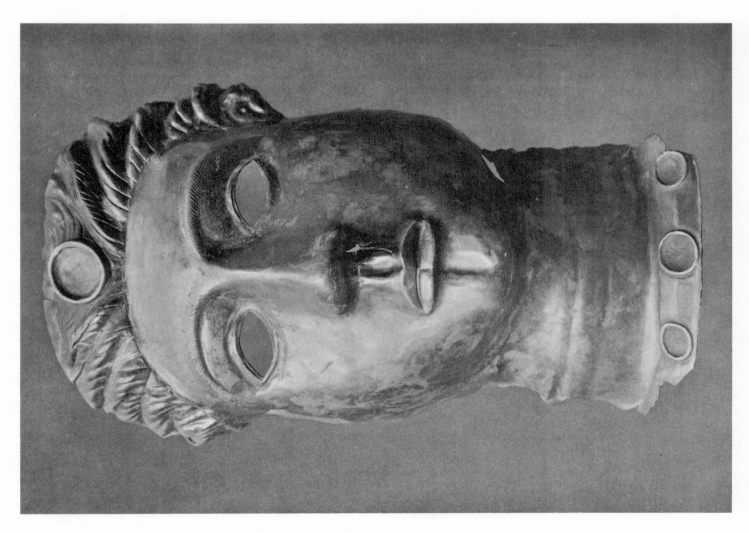

105, 106. Silver masks of Minerva.
Paris. Louvre, Salle des bijoux.

PLATE 34

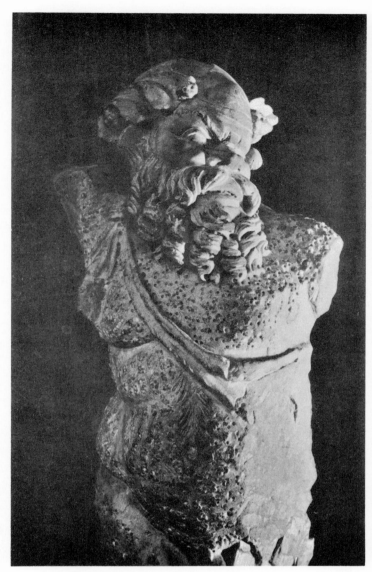
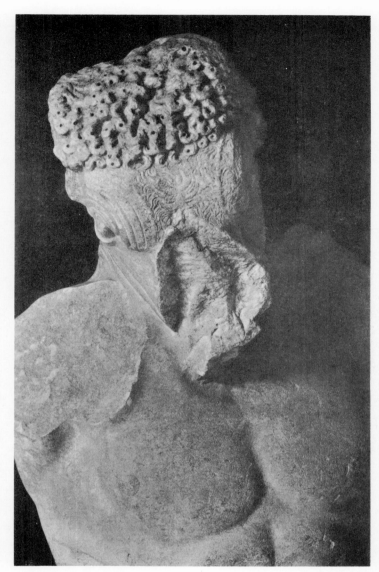

107, 108. Silene.
Rome, Museo, Nazionale.

109. Roman panel of masks in the Dionysos Theatre in Athens.
Present condition.

PLATE 35

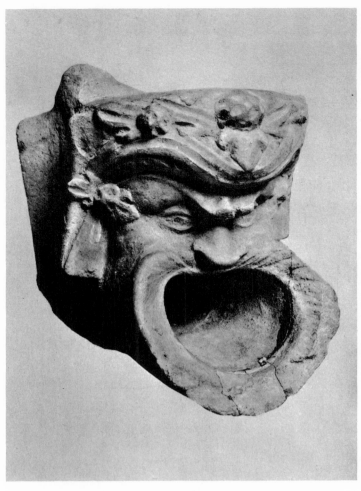

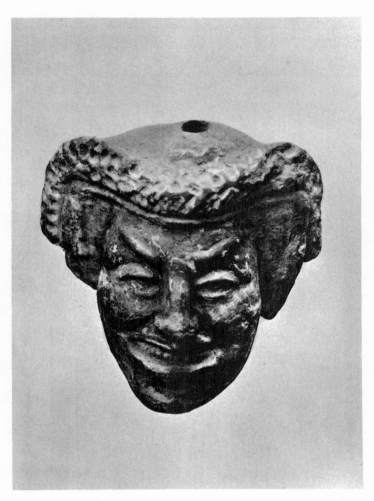

110. **Satyr Mask, Rain water pipe. Terracotta. Italian.**
Milan, Museo della Scala.

111. **Mask of a woman. Terracotta (oscillum). Hellenistic.**
Milan, Museo della Scala.

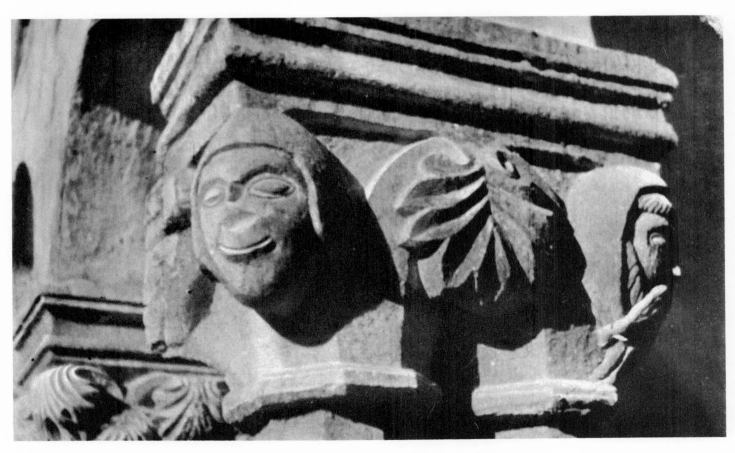

112. **Capital in the transept of the Franciscan Convent.**
Dubrovnik. (Ragusa) Dalmatia.

PLATE 36

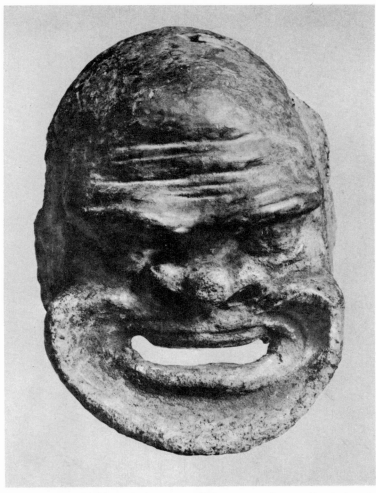

113. Mask of a comic ancient. Terracotta. Hellenistic.
Milan, Museo della Scala.

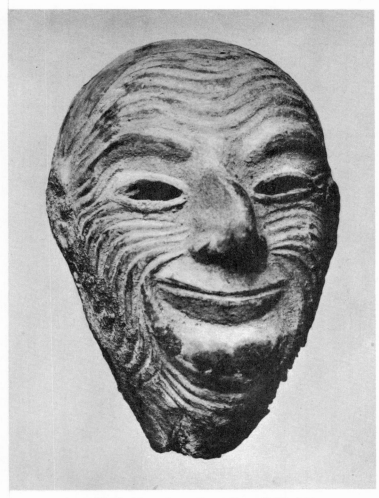

114. Mask of ancient. Terracotta. Hellenistic.
Milan, Museo della Scala.

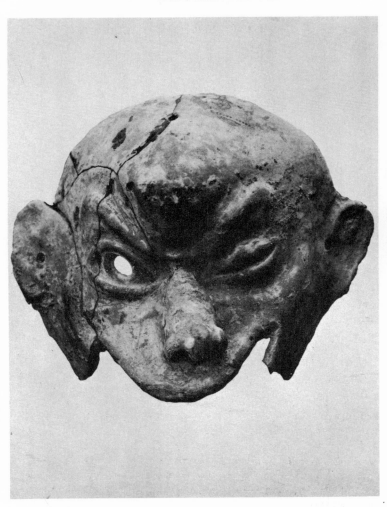

115. Mask with double face. Terracotta. Pre-Roman, Naples.
Milan, Museo della Scala.

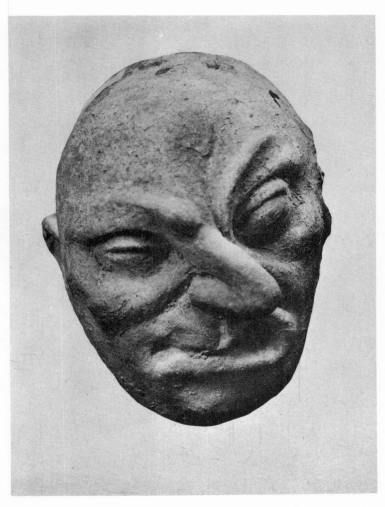

116. Mask with double face. Hellenistic.
Milan, Museo della Scala.

PLATE 37

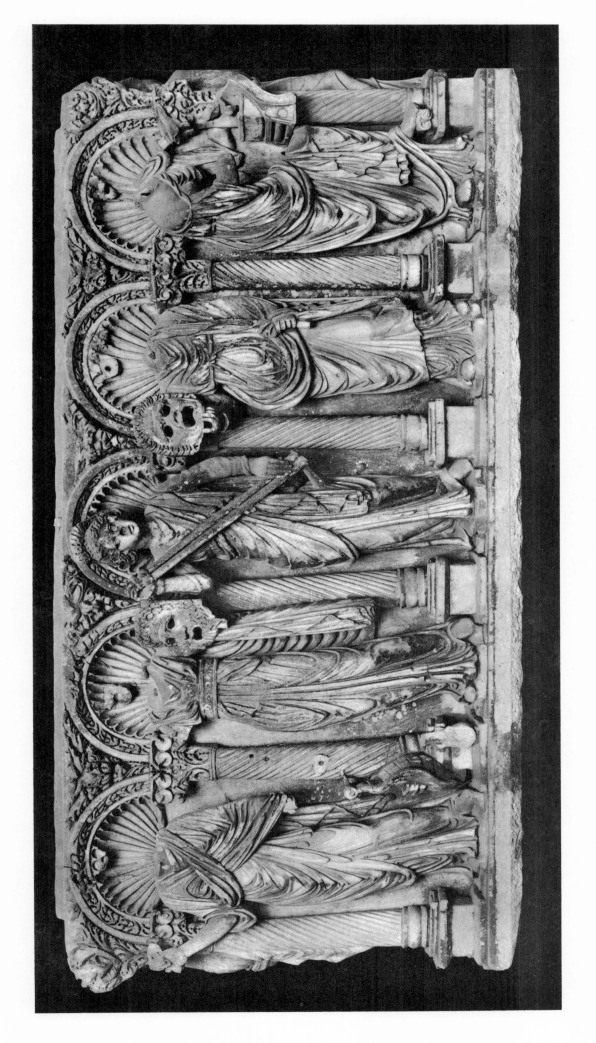

117. Sarcophagus. Apollo and the Muses.
Rome, Museo Nazionale.

PLATE 38

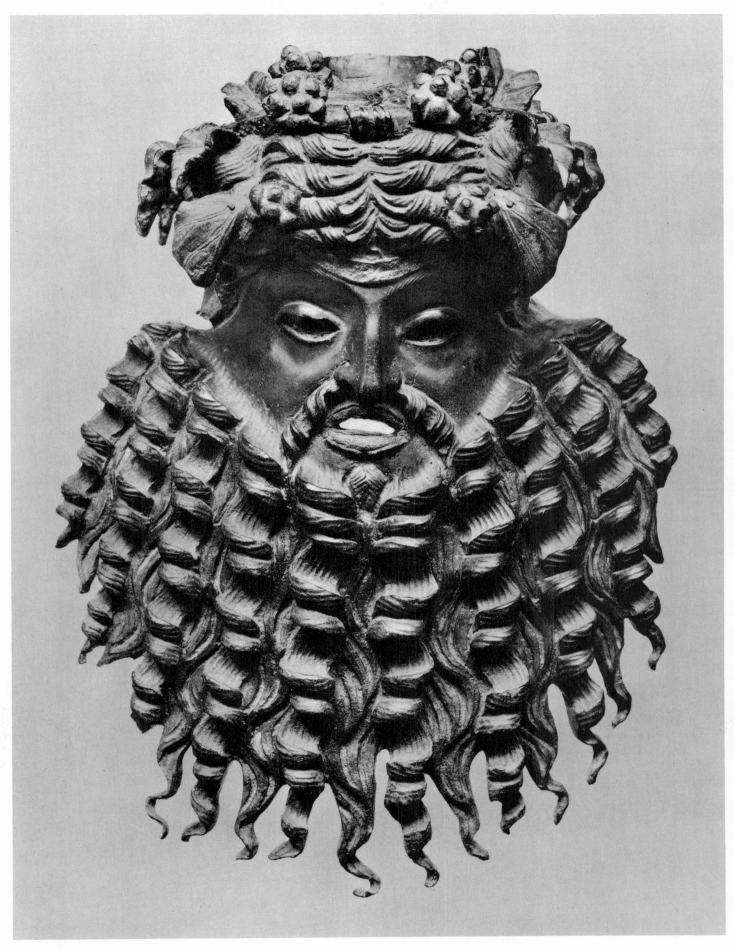

118. Mask of Dionysos, Bronze.
Vienna, Kunsthistorisches Museum.

PLATE 39

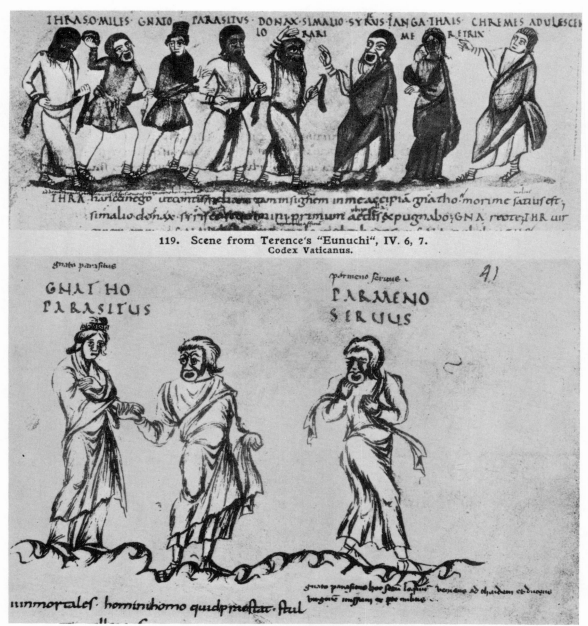

119. Scene from Terence's "Eunuchi", IV. 6, 7.
Codex Vaticanus.

120. Scene from Terence's "Eunuchi", II. 2.
Codex Vaticanus.

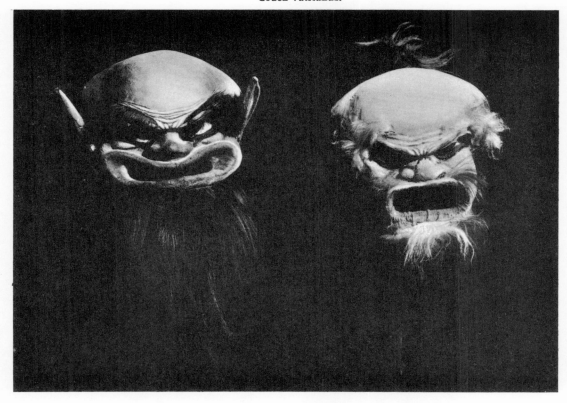

121. Silene. Masks for the performance in the Theatre of Syracuse. Present day.

PLATE 40

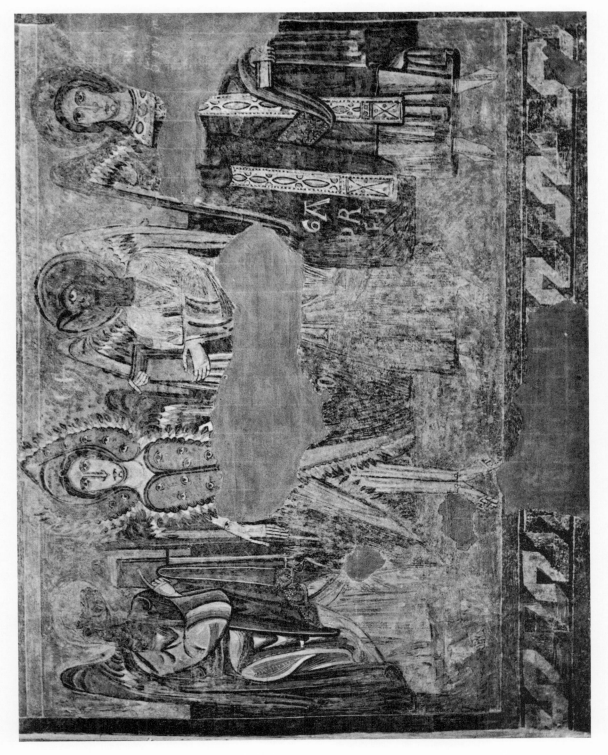

122. S. Maria de Tahull, XII. Cent. Fresco.
Barcelona, Museum of Catalonian Art.

PLATE 41

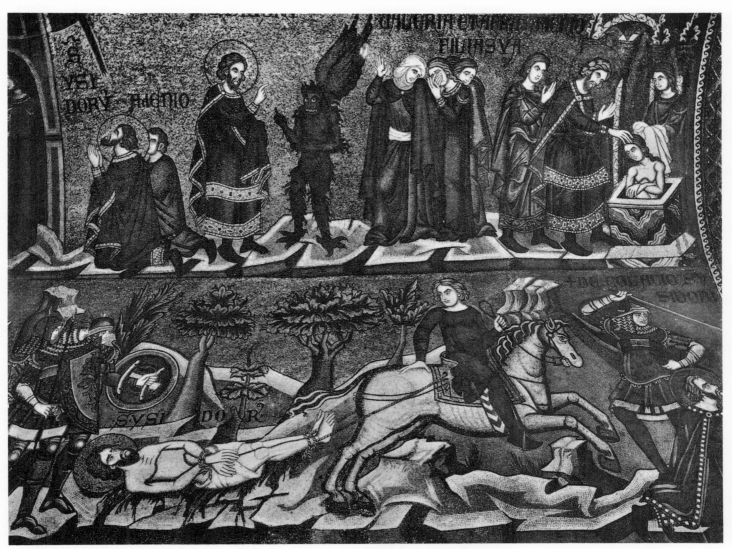

123. Mosaic. St. Marks, Chapel of St. Isidore.
Episode of his Life. 14th century.
Venice, St. Marks.

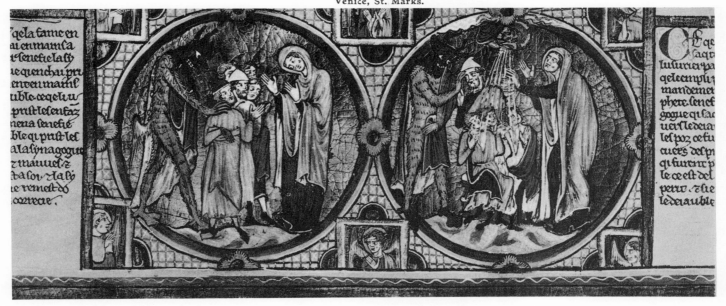

124. Picture Bible. French, 14th century.
Vienna, National Library. Cod. 2554.

PLATE 42

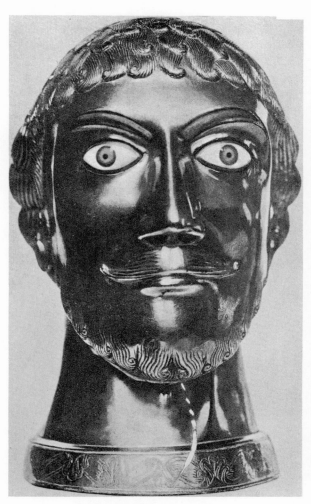

125. Reliquary of St. Vitus.
Cologne.

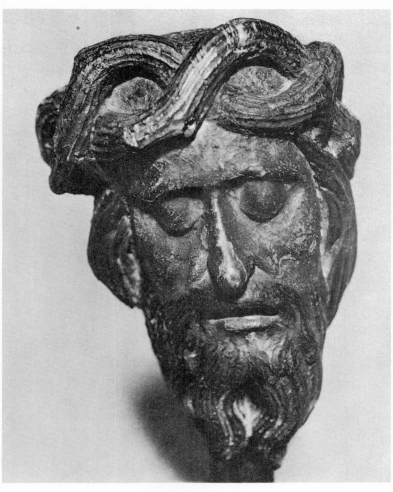

126. Head of Christ.
Paris, Musée de Cluny.

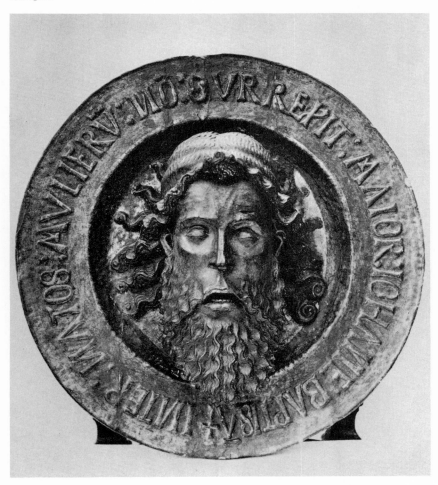

127. Head of John the Baptist. End of 15th century.
Paris, Musée de Cluny.

PLATE 43

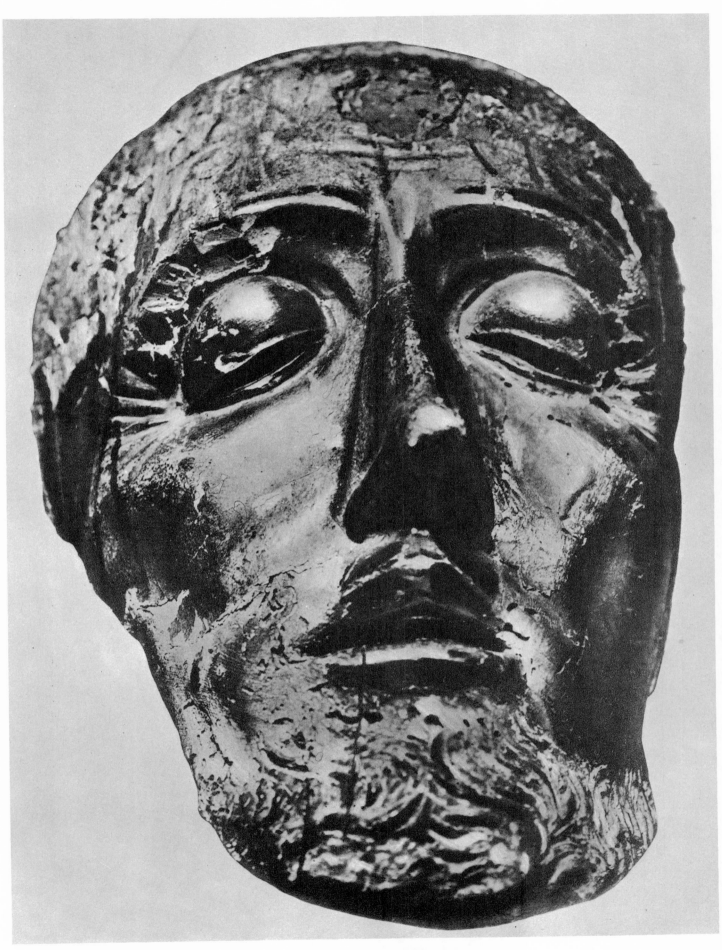

128. Mask of Christ, South German. About 1570.

PLATE 44

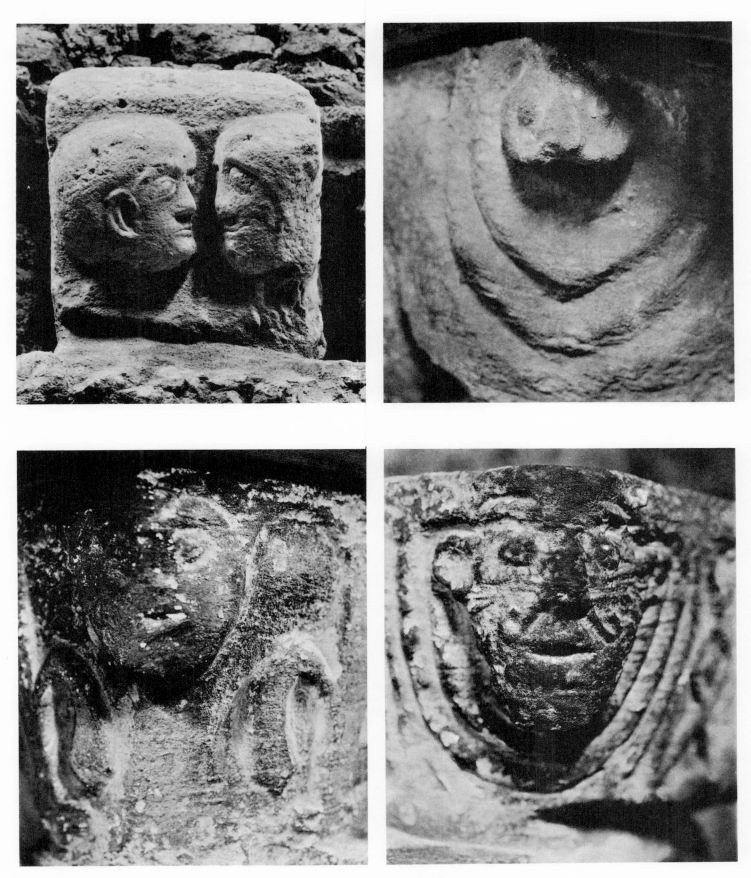

129—132. Stone mask capitals.
Paris, Musée de Cluny.

PLATE 45

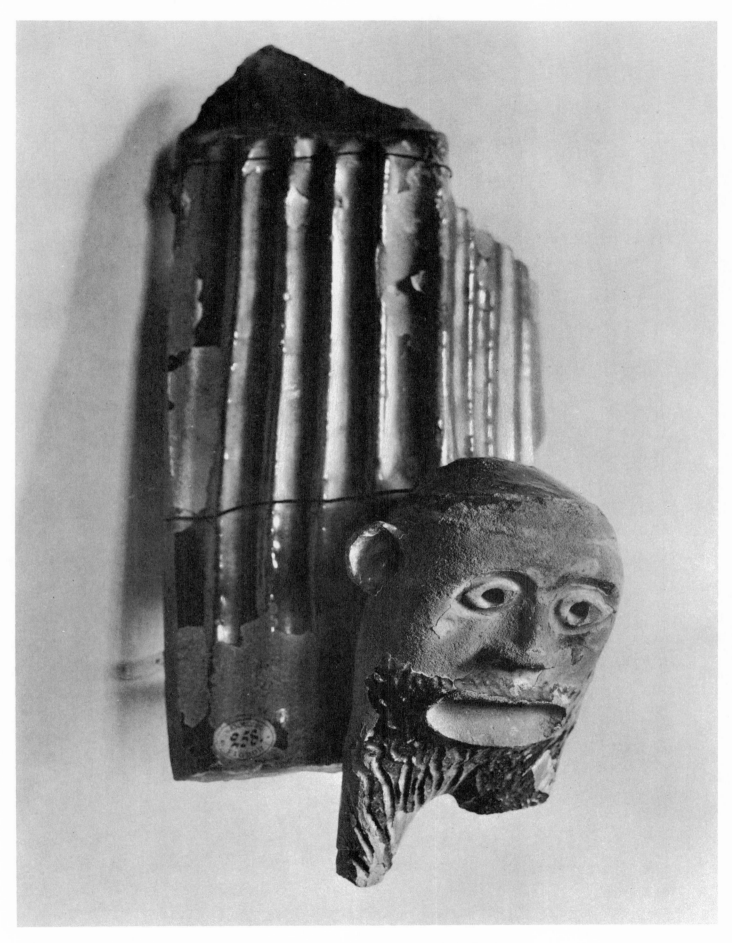

133. Ridge Tile from the green tower in Ravensburg
(Würt.) German, 14th century.
Vienna, Figdor Collection.

PLATE 46

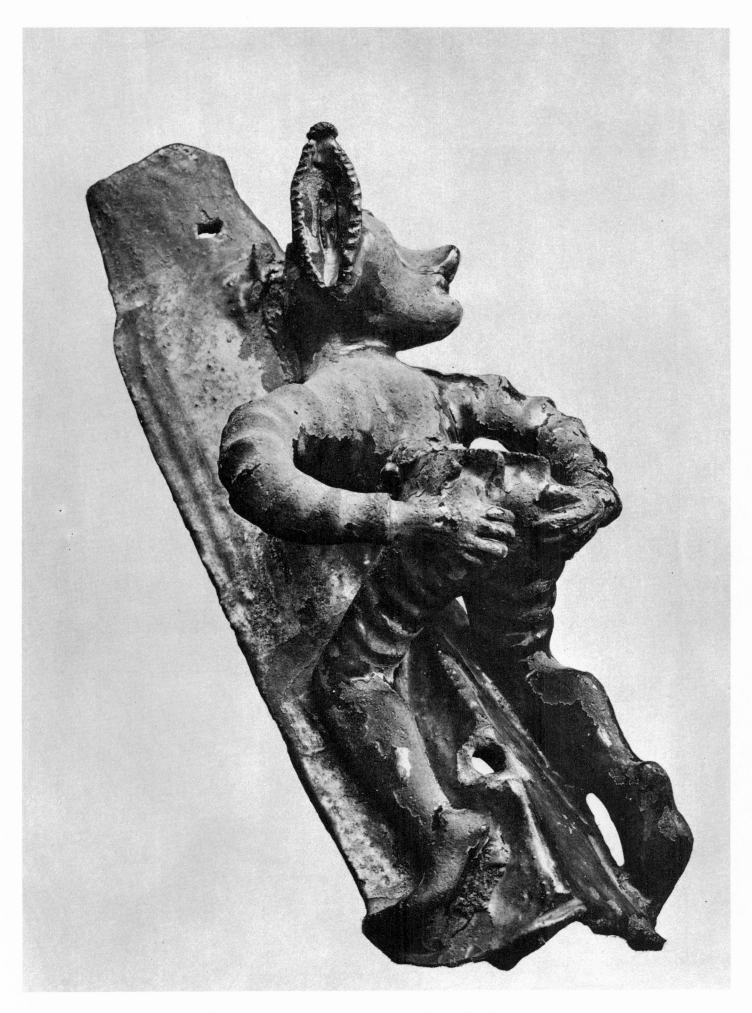

**134. Roof Tile from the Church or the Holy Cross,
Schwäb-Gmünd. 14th century.**
Vienna, Figdor Collection.

PLATE 47

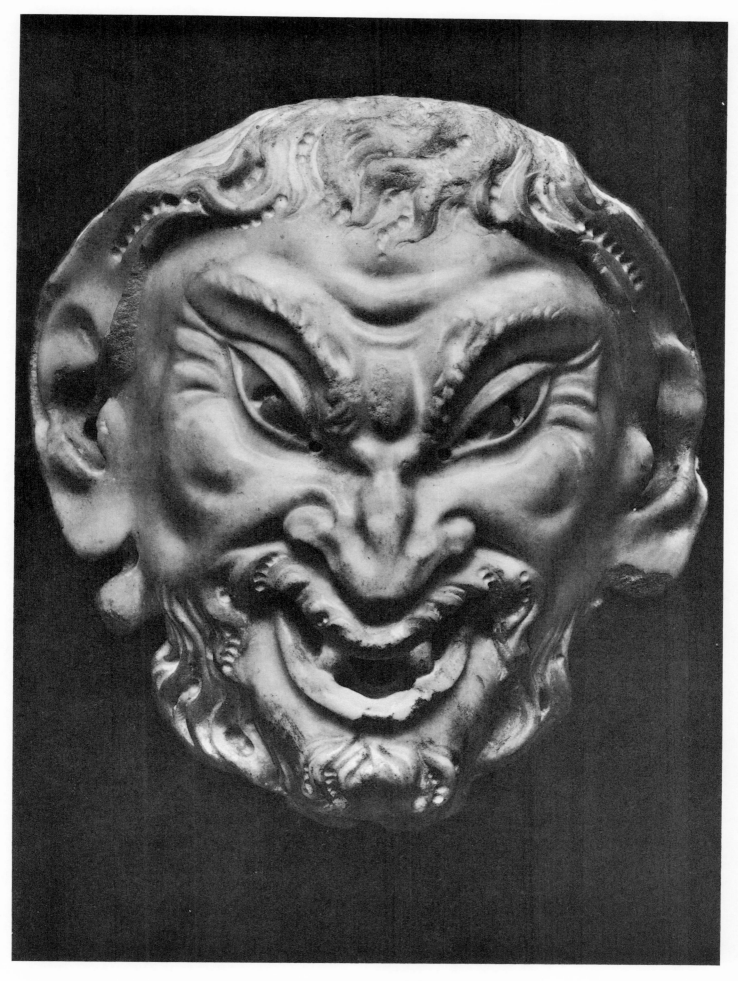

**135. Mask of a Faun. Marble. Unknown Italian master of the
17th century (formerly incorrectly ascribed to Michélangelo).**
Florence, Museo Nazionale.

PLATE 48

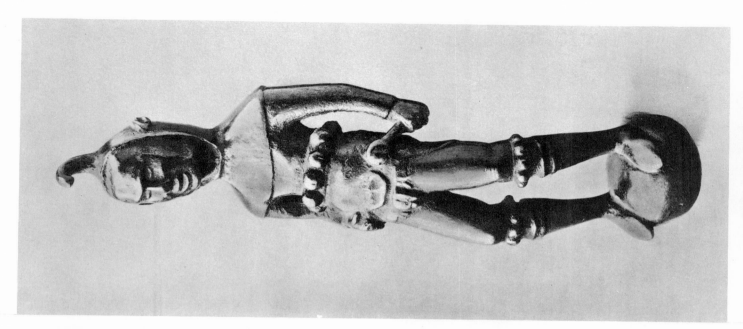

138. Door knocker, French,
first half of 16th century.
Vienna. Figdor Collection.

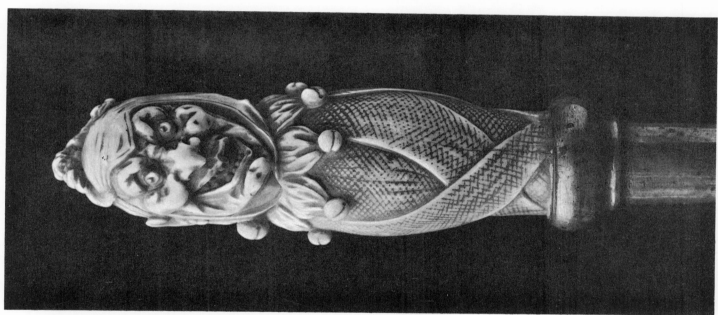

137. Head of a Fool's sceptre (Marotte) French, 18th century.
Ivory.
Vienna. Figdor Collection.

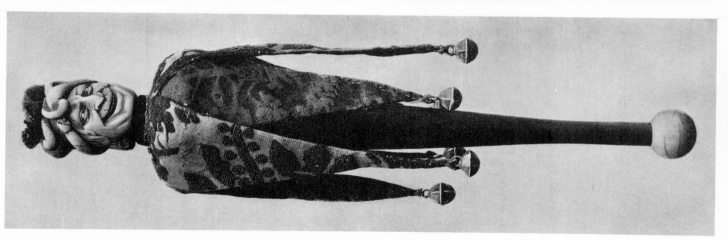

136. Fool's sceptre (Marotte).
French, 16th century.
Vienna. Figdor Collection.

PLATE 49

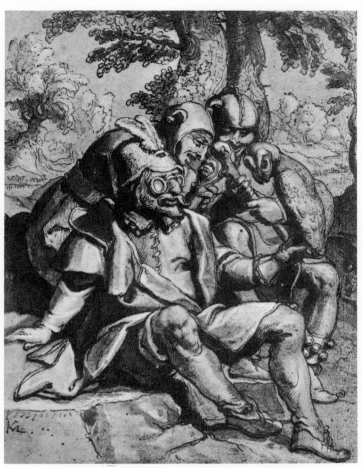

139. Karel van Mander. Group of Fools. Drawing.
Vienna, Albertina.

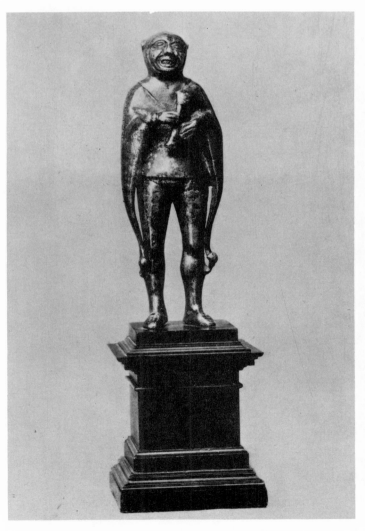

140. Statuette of fool. Northern France.
Vienna, Figdor Collection.

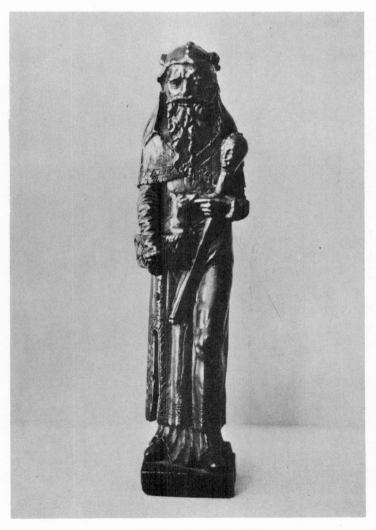

141. Nutcracker, Flemish.
Vienna, Auspitz Collection.

PLATE 50

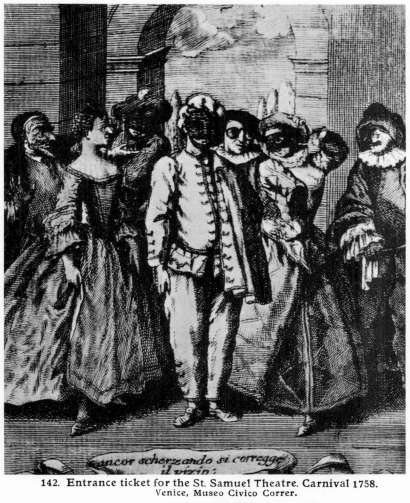

142. Entrance ticket for the St. Samuel Theatre. Carnival 1758.
Venice, Museo Civico Correr.

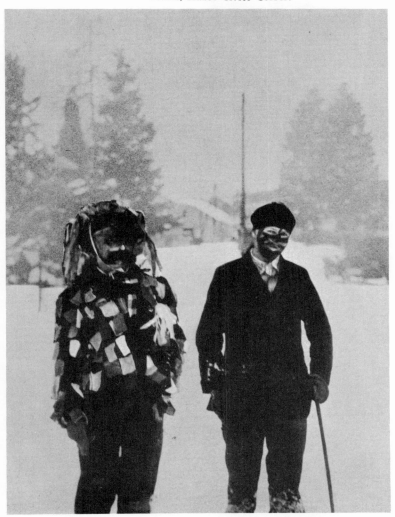

143. Carnival, masks in the Wienerwald 1933.
Photograph Vienna, National Library.

PLATE 51

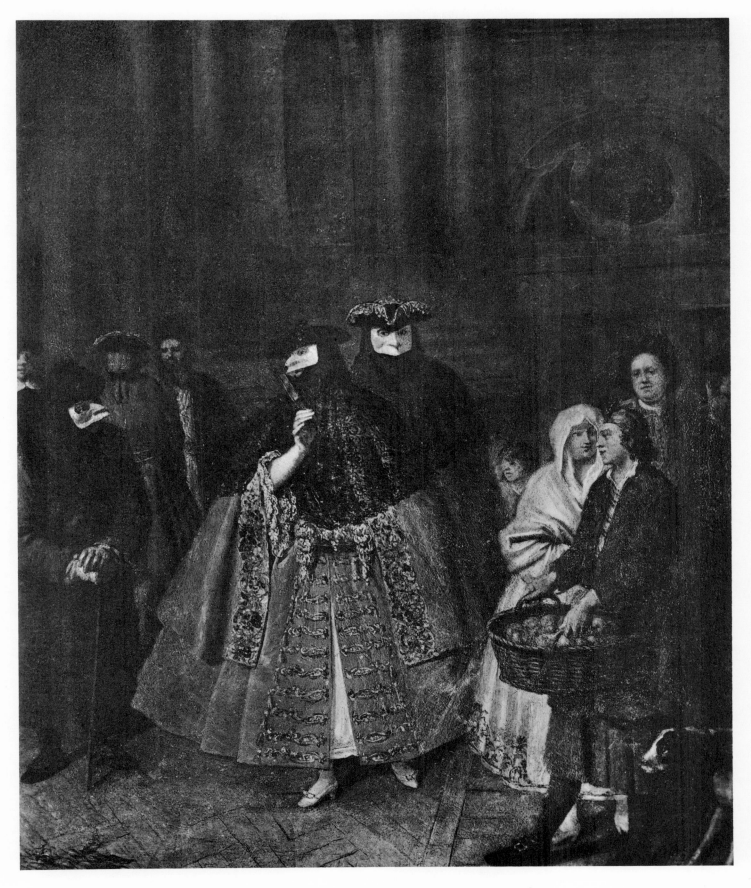

144. P. Longhi: Street scene.
Venice, Museo Civico Correr.

PLATE 52

145—147. Mask head (left) and mask forms (matrices).
Venetian, 18th century.
Venice. Museo Civico Correr.

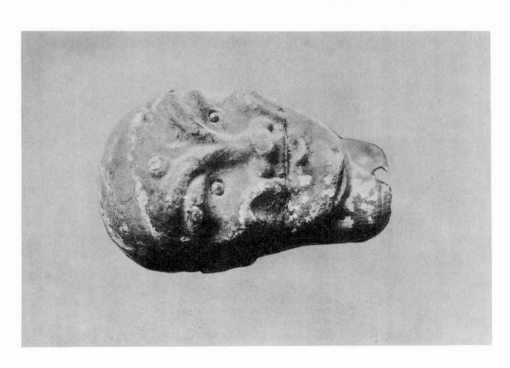

PLATE 53

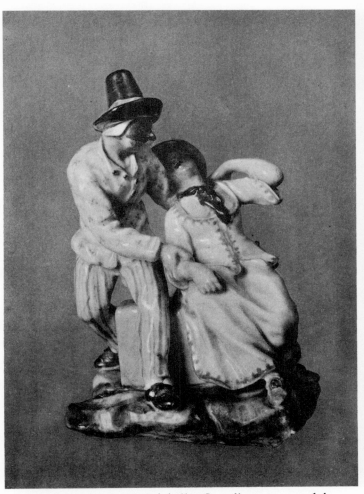

148. Columbine and Brighella. Capodimonte porcelain.
18th century.
Milan, Museo della Scala.

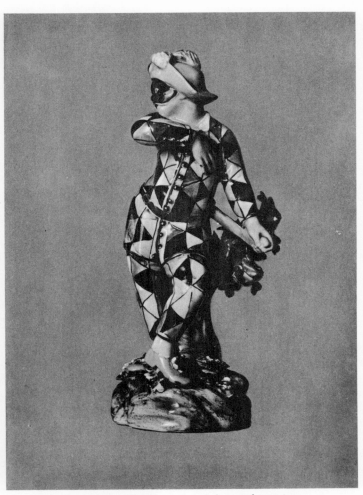

149. Harlequin. Chelsea porcelain. 18th century.
Milan, Museo della Scala.

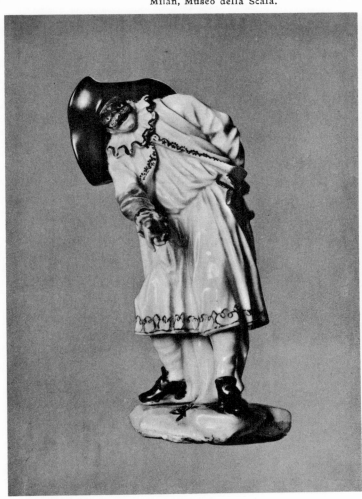

150. The Doctor, Capodimonte porcelain. 18th century.

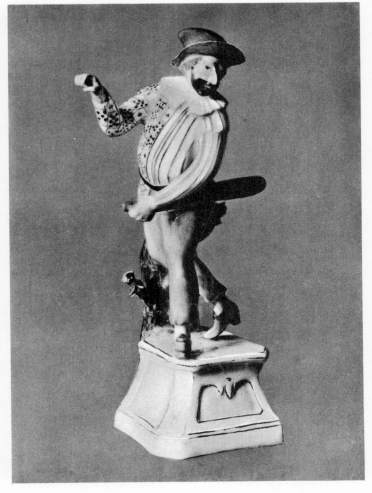

151. Harlequin. Dresden porcelain. 18th century.
Milan, Museo della Scala.

PLATE 54

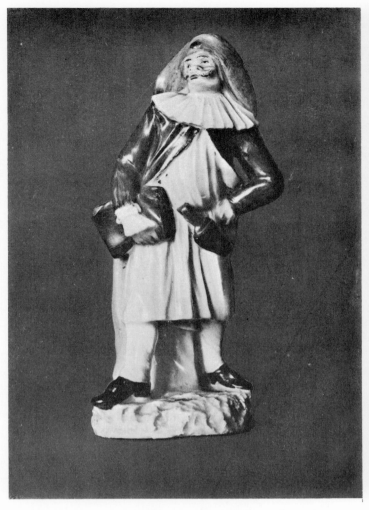

152. The Doctor. Capodimonte porcelain. 18th century.
Milan, Museo della Scala.

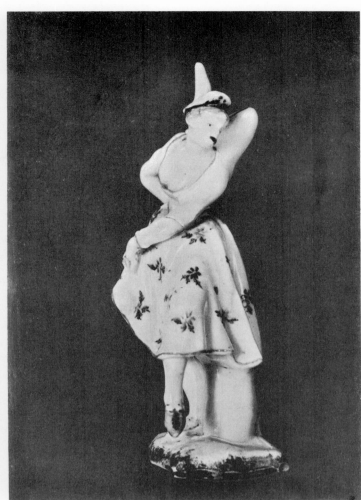

153. Punchinella. Capodimonte porcelain. 18th century.
Milan, Museo della Scala.

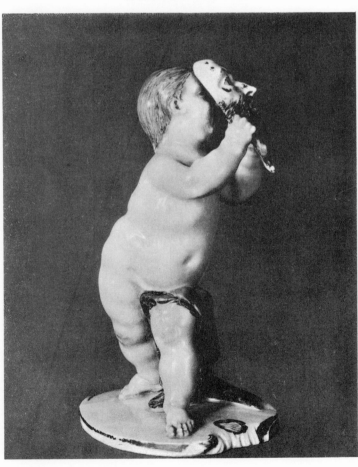

154. Cupid with mask. Nymphenburg porcelain.
18th century.
Milan, Museo della Scala.

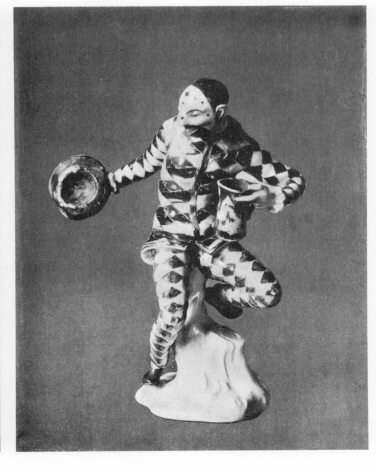

155. Harlequin. Dresden porcelain. 18th century.
Milan, Museo della Scala.

PLATE 55

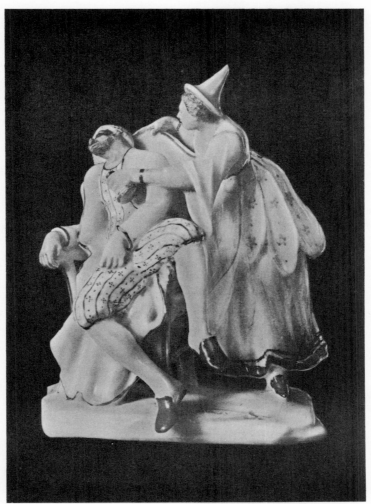

156. Comedy Scene Capodimonte porcelain.
18th century.
Milan, Museo della Scala.

157. Comedy Scene Capodimonte porcelain.
18th century.
Milan, Museo della Scala.

PLATE 56

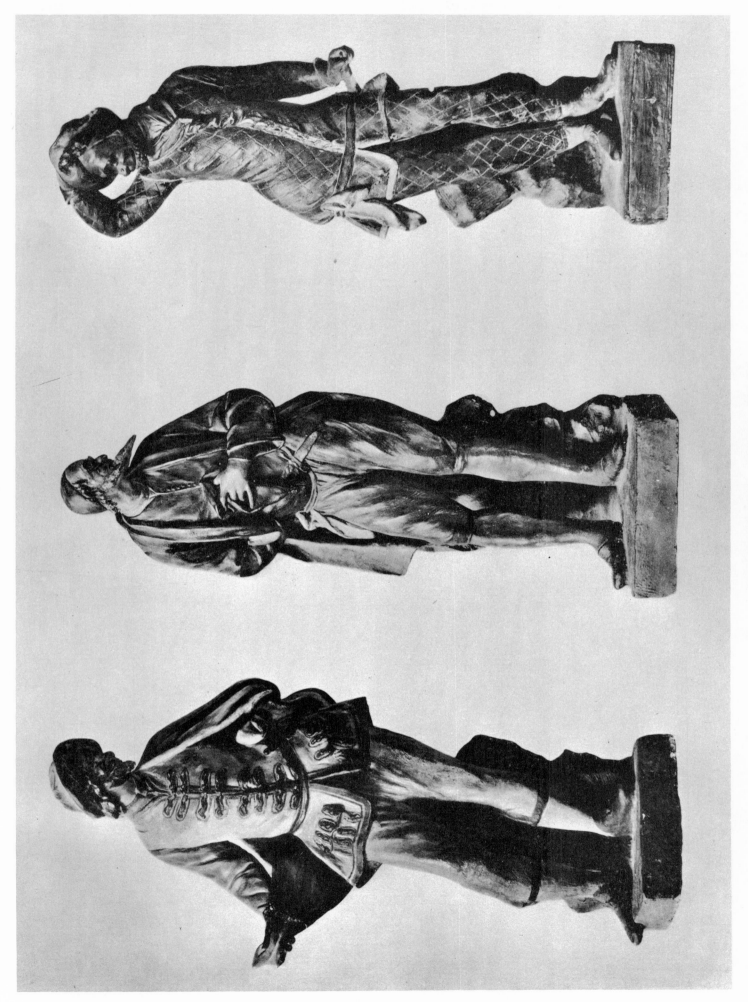

158. a—c Brighella, Pantaloon, Harlequin. Venetian
statuettes in coloured terracotta. 18th century.
Milan, Museo della Scala.

PLATE 57

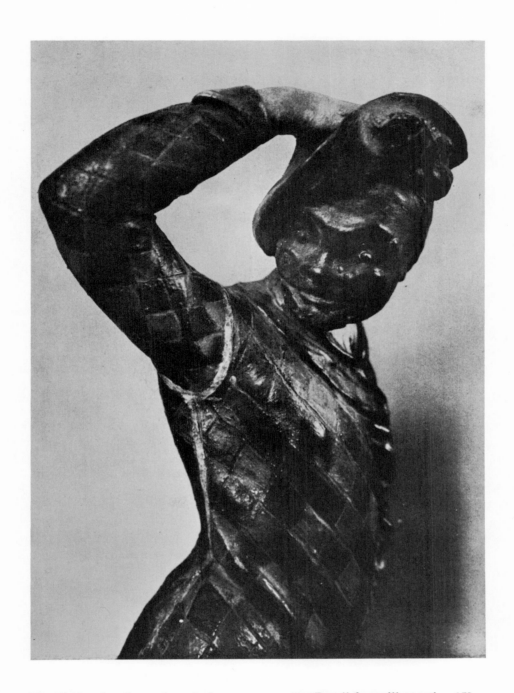

159. **Harlequin. Statue in polychrome terracotta. Detail from illustration 158, c.**
Milan, Museo della Scala.

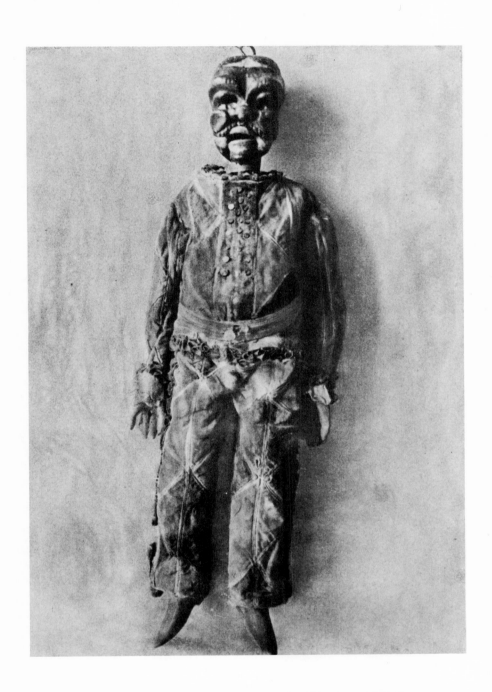

160. Harlequin. Marionette of wood and cloth. Venetian. 18th Century.
Milan, Museo della Scala.

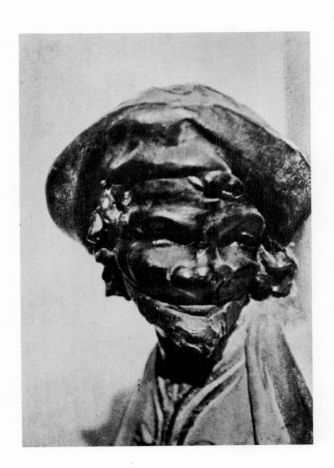

161. Brighella. Polychrome terracotta statue. Venetian. 18th Century.
Detail from illustration 158, a.
Milan, Museo della Scala.

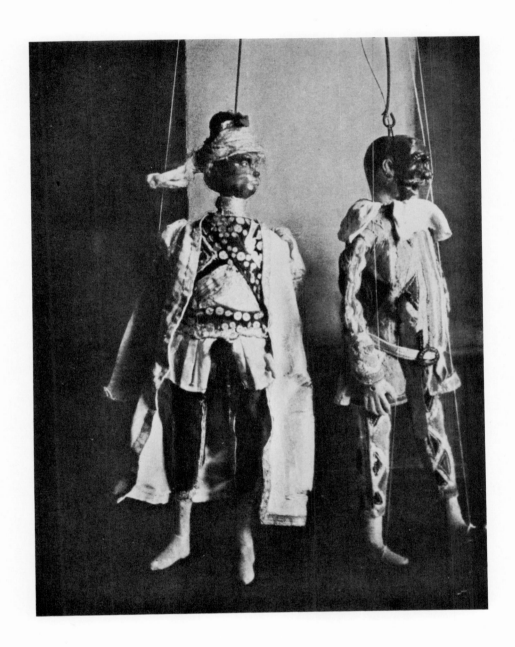

162. Doll's Theatre. Venetian. 18th Century.
Venice, Museo Civico Correr.

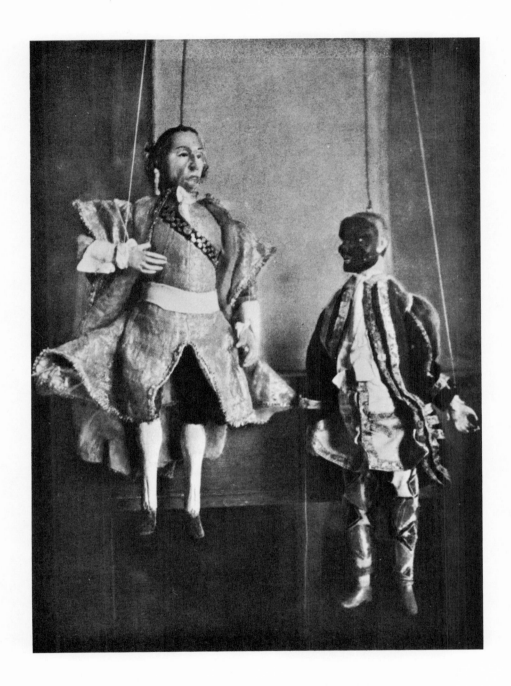

163. Doll's Theatre. Venetian. 18th Century.
Venice, Museo Civico Correr.

PLATE 60

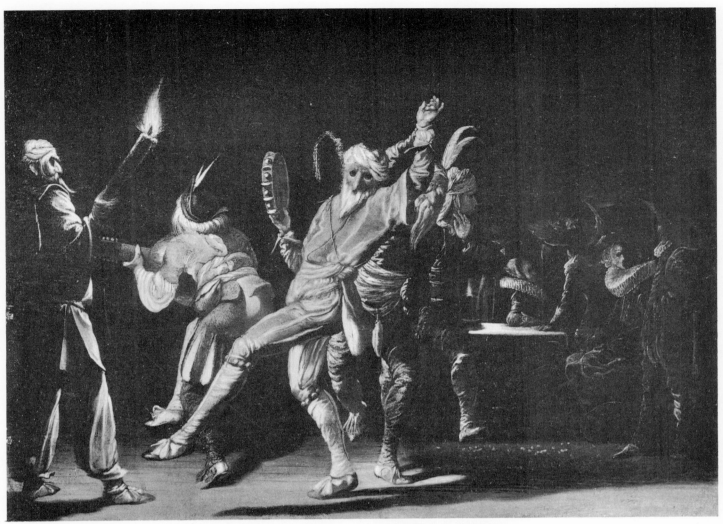

164. Cornelis Duyster: Carnival Jesters. Painting.
Berlin, Friedrichs Museum.

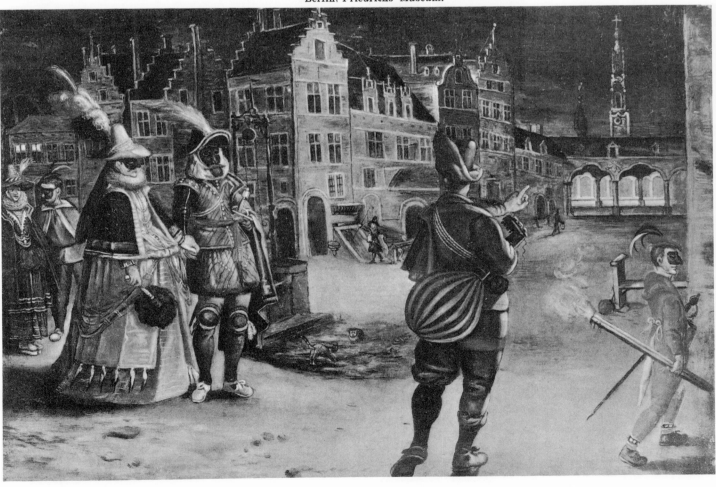

165. Sebastian Vrancx: Carnival.
Cologne, Wallraf-Richartz-Museum.

PLATE 61

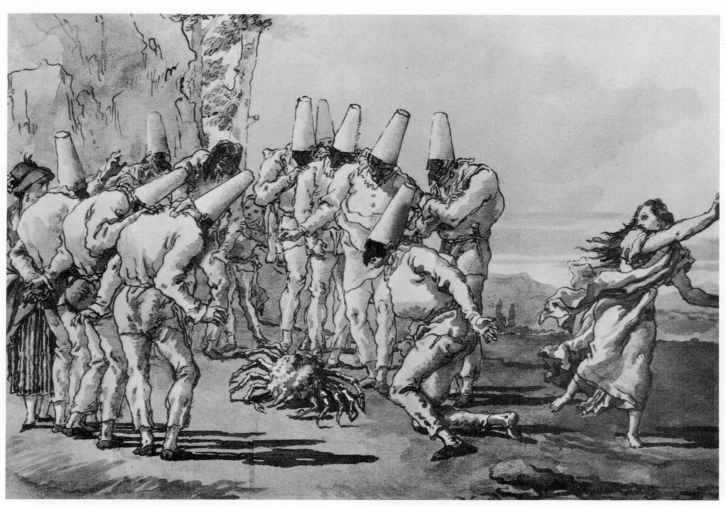

166. Tiepolo: Punchinello. Drawing. Venice. Exhibition of the 18th century.
Rome, private ownership.

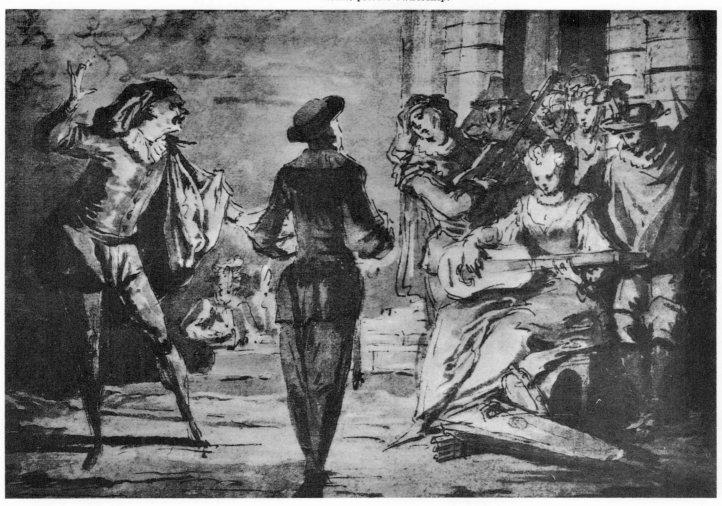

167. Impromptu Comedians. Drawing.
Paris, Louvre.

PLATE 62

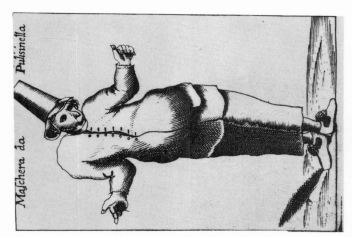

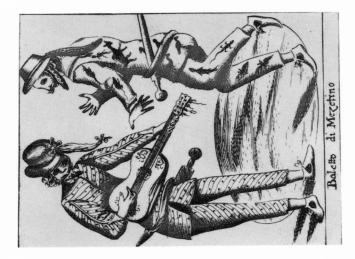

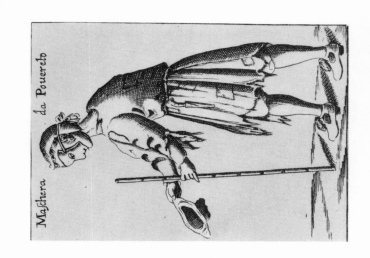

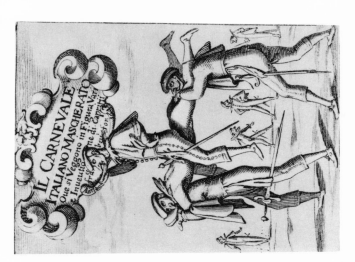

168–175. Italian Mask Carnival. "Ove si Veggono in Figure Varie Inventione di capritii" (1642). Munich, Theatermuseum.

PLATE 63

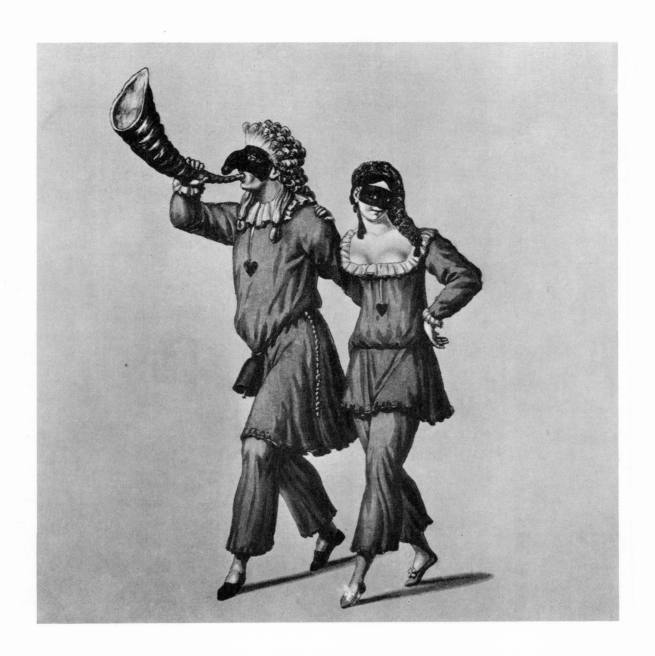

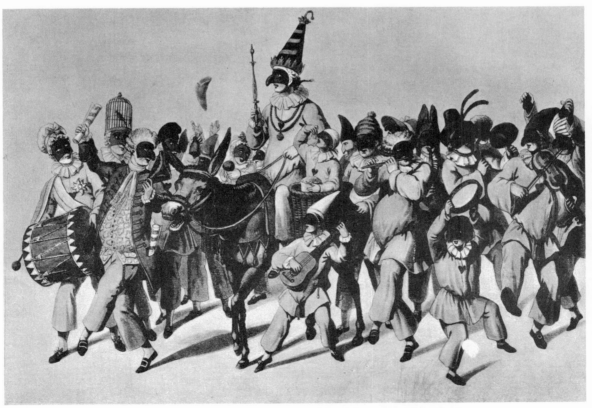

176, 177. Masks of the Roman Carnival (above. Punchinellos).
F. Valentini. "Abhandlung über die Comödie
aus dem Stegreif". Berlin 1826.
Vienna, National Library.

PLATE 64

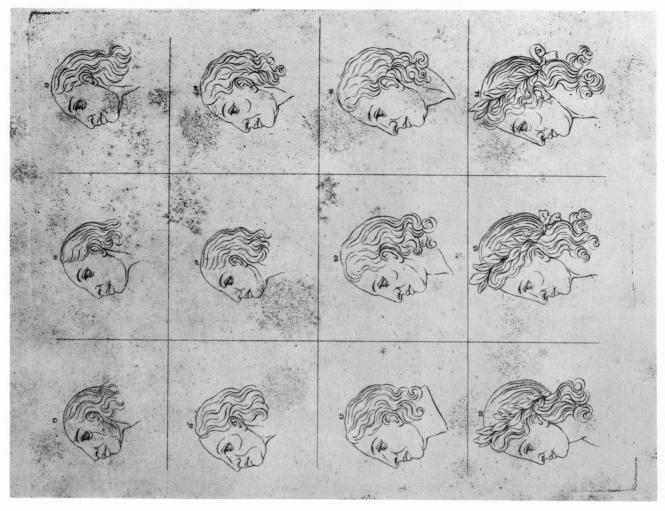

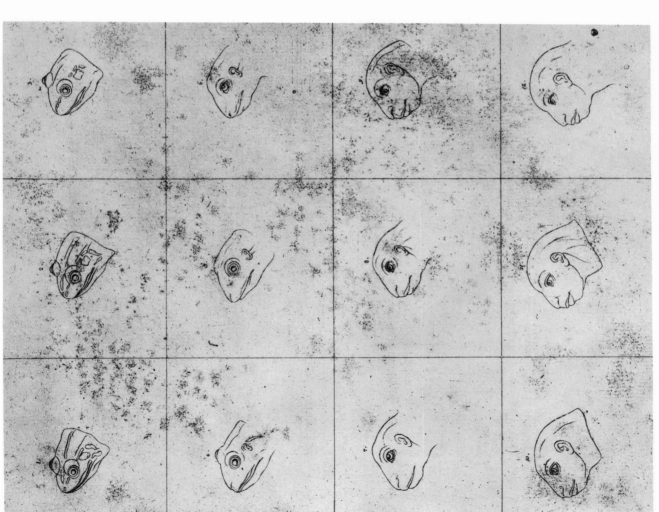

178, 179. Gaspar Lavater: "L'Art de connaître les hommes par la Physionomie"
Volume IX. Paris 1807.

24 heads presumably the change of a Frog Mask into the Mask of Apollo
through the alteration of the lines of the face. Copper engraving.
Vienna, National Library.

PLATE 65

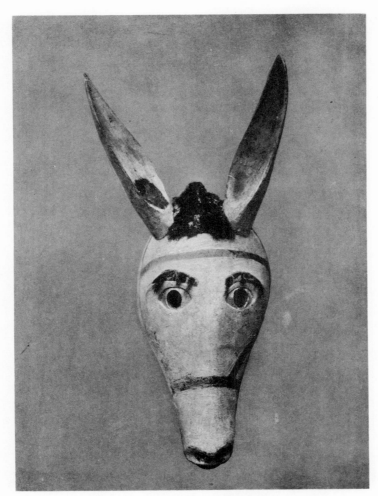

180. Animal mask.
Salzburg, Städtisches Museum.

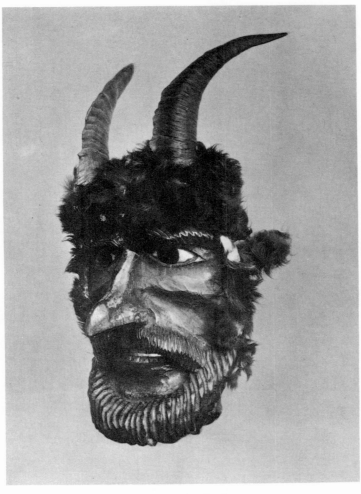

181. Devil Mask.
Salzburg, Städtisches Museum.

PLATE 66

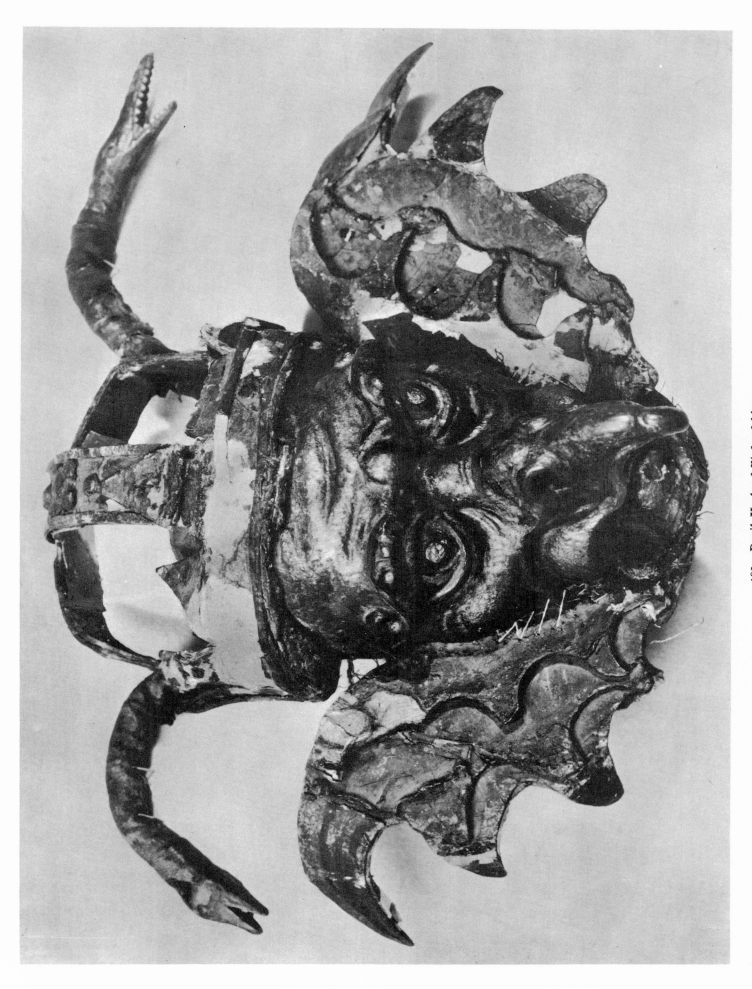

182. Devil Mask of Kiefersfelden.
(Dr. Hans Moser, Munich).

PLATE 67

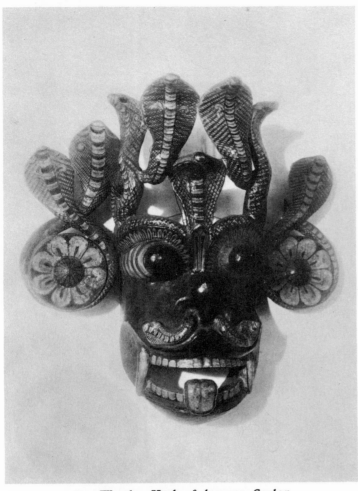

183. Wooden Mask of demons, Ceylon.
Vienna, Museum für Völkerkunde.

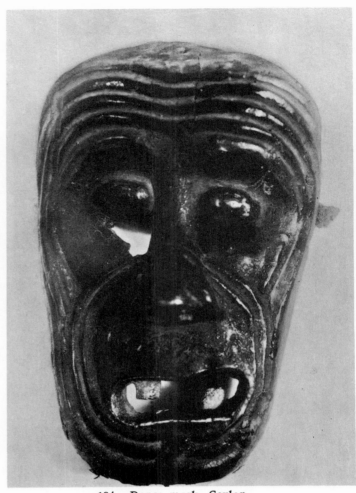

184. Dance mask, Ceylon.
Vienna, Museum für Völkerkunde.

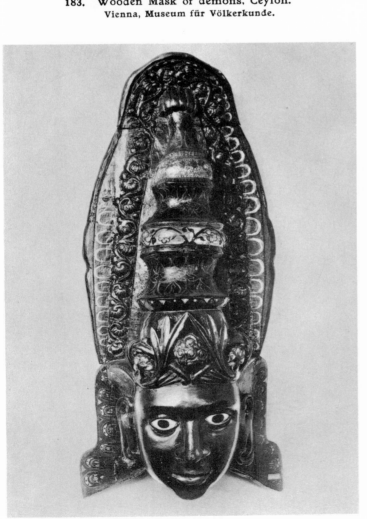

185. King's mask of Wood, Ceylon.
Vienna, Museum für Völkerkunde.

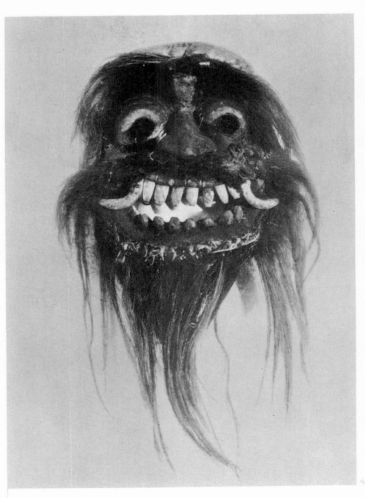

186. Face of a demon with moveable lower jaw, worn to prevent chills. Ceylon
Vienna, Museum für Völkerkunde.

PLATE 68

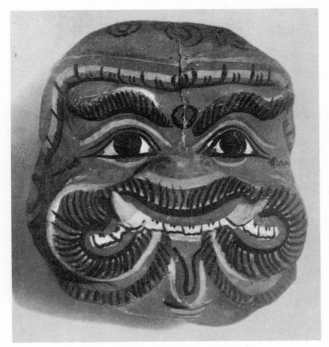

187. Theatre mask of paper-mâché, Burma.
Vienna, Museum für Völkerkunde.

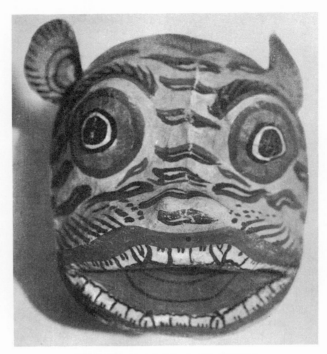

188. Paper-mâché mask, Burma.
Vienna, Museum für Völkerkunde.

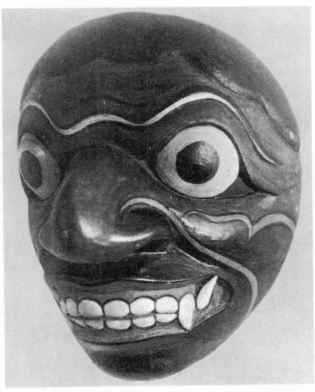

189. Demon mask of wood. (Rakschasa Masks). Java.
Vienna, Museum für Völkerkunde.

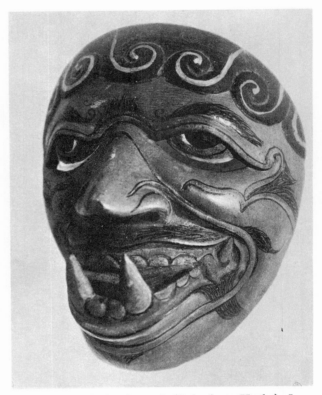

190. Demon mask of wood. (Rakschasa Masks). Java.
Vienna, Museum für Völkerkunde.

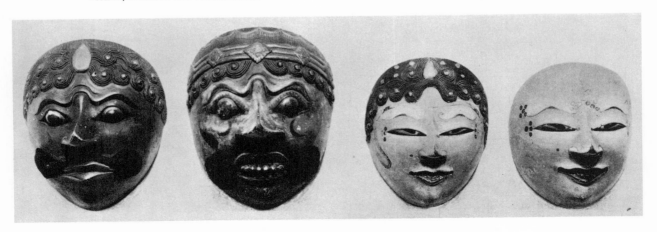

191. Miniature masks. Java.
Leyden, Rijks Ethnographisch Museum.

PLATE 69

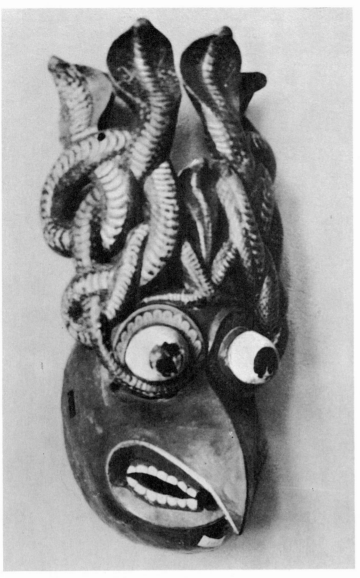

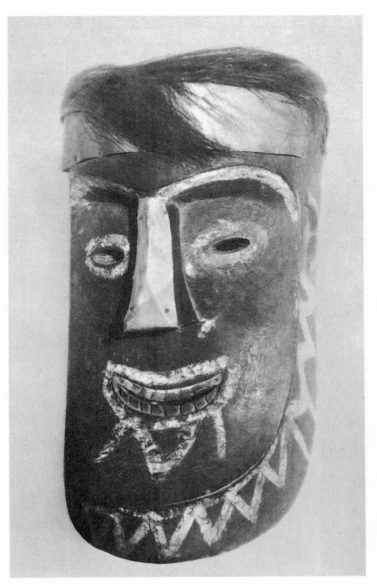

192. **Mask of a Singhalese devil-dancer. "Gurula sayäge"**
(King of the birds).
Stettin, Museum für Kunstgewerbe.

193. **Wooden mask, inlaid with metal. "Guru". Sumatra.**
Vienna, Museum für Völkerkunde.

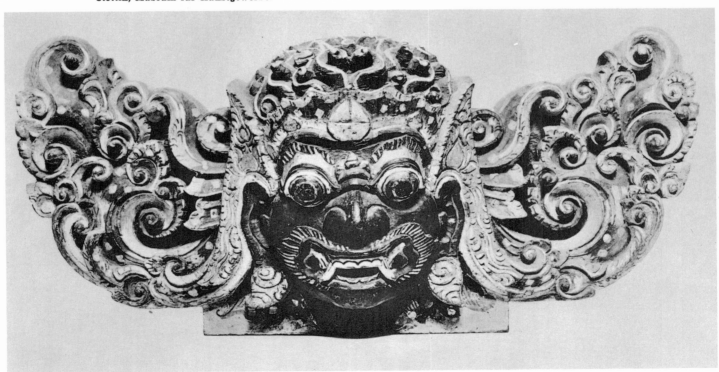

194. **Coloured wooden relief from Bali.**
Leyden. Rijks Ethnographisch Museum.

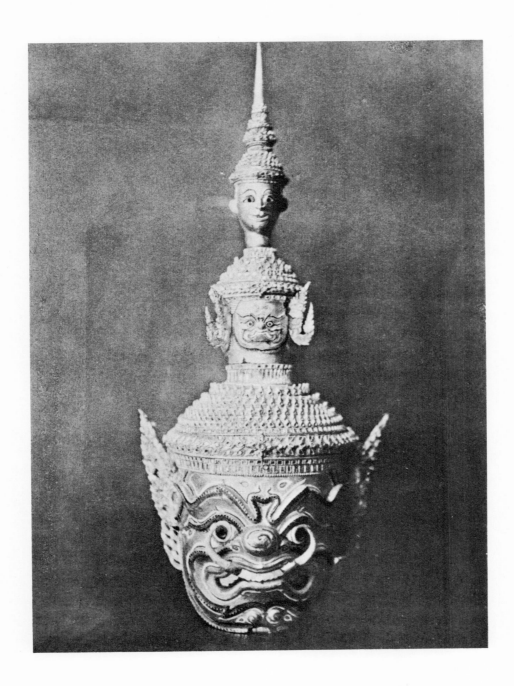

195. **Mask of the Demon Prince Rāvana, made of papier-mâché, gilded, painted and set out with bits of looking-glass. (Lakon Mask). Siam.**
Berlin, Museum für Völkerkunde. Riebeck Collection.

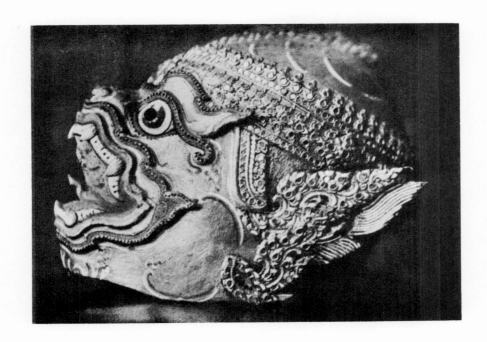

196. Mask. "Ling" (Ape). Siam.
Berlin, Museum für Völkerkunde. Lessler Collection.

PLATE 71

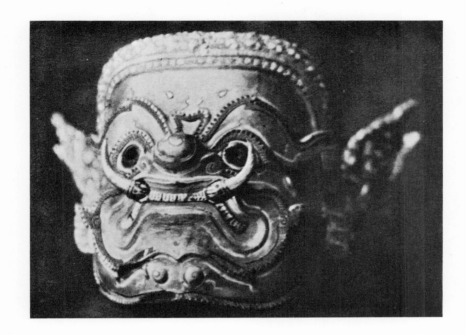

197. Mask. "Yksa" (Demon). Siam.
Berlin, Museum für Völkerkunde. Lessler Collection.

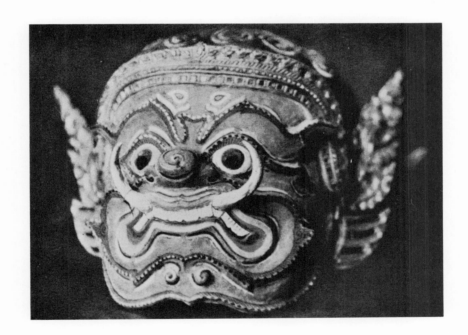

198. A soldier. (Lakon Mask). Siam.
Berlin, Museum für Völkerkunde. Riebeck Collection.

PLATE 72

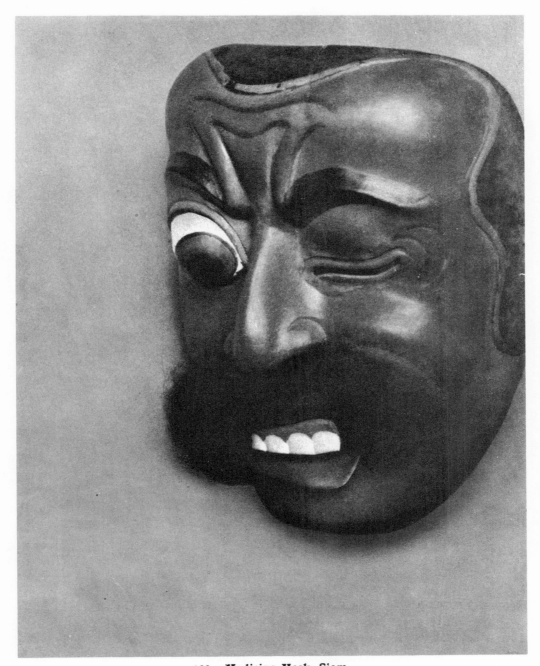

199. Medicine Mask. Siam.
Berlin, Museum für Völkerkunde.

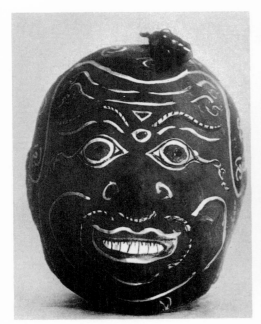 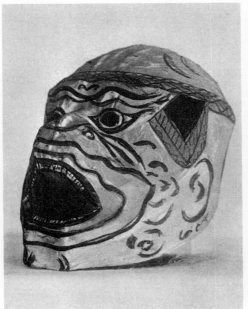 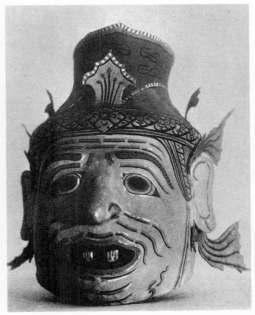

200—202. Theatre masks made of paper, Siam.
Vienna, Museum für Völkerkunde.

PLATE 73

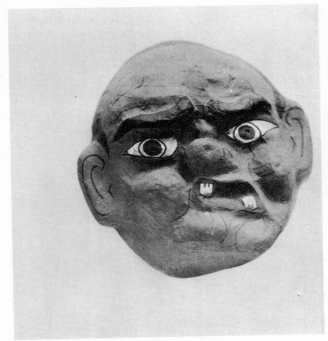

203. Paper-mâché mask. China.
Leyden, Rijks Ethnographisch Museum.

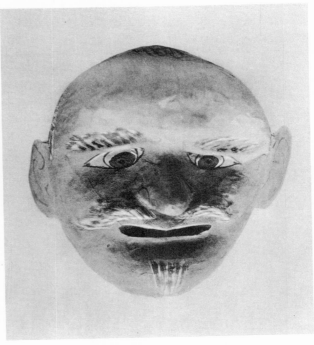

204. Paper-mâché mask. China.
Leyden, Rijks Ethnographisch Museum.

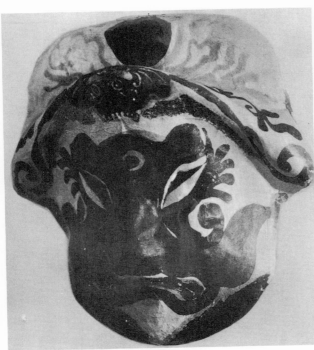

205. Paper-mâché theatre mask. China.
Vienna, Museum für Völkerkunde.

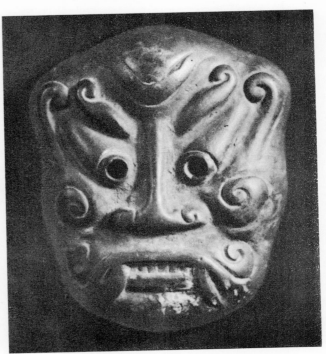

206. Miniature Mask. China. Bronze.

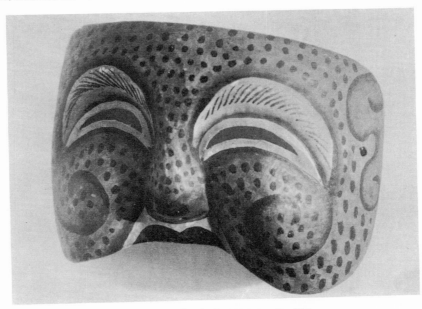

207. Paper-mâché theatre mask. China.
Vienna, Museum für Völkerkunde.

PLATE 74

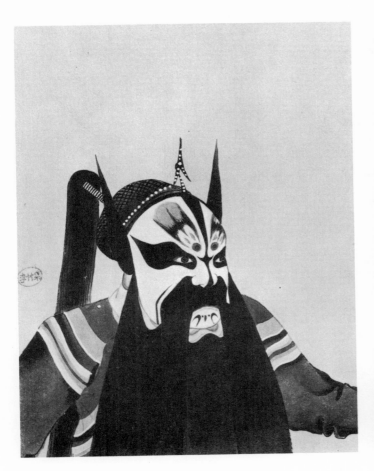
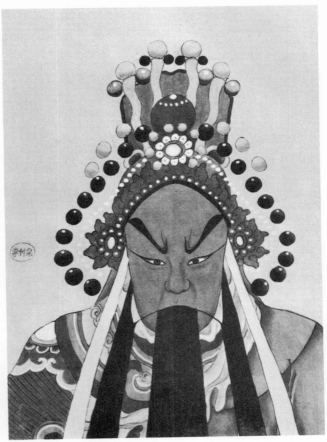
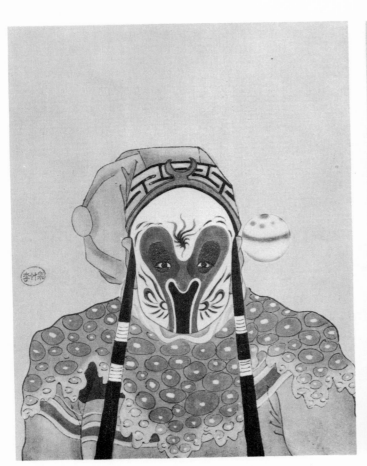
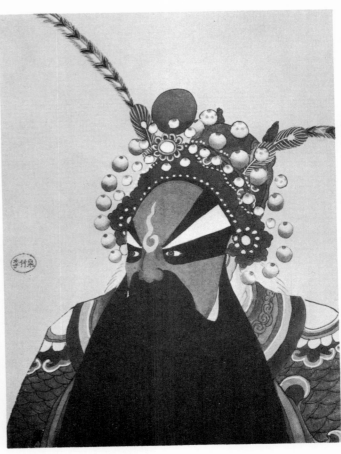

208—211. **Tscheng Jen-Tsio, Beauty mask of the Chinese
theatre. Contemporary.**
Vienna, National Library.

PLATE 75

 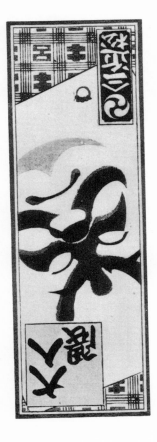 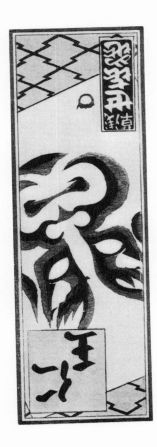 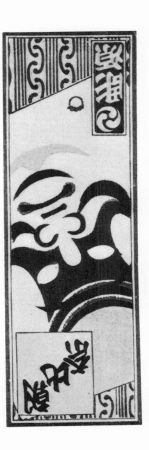

212. a—d. Four leaves from a pattern book of
beauty Masks· Japan (Bild umkehren)

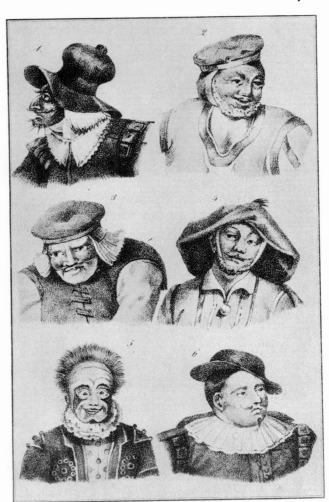 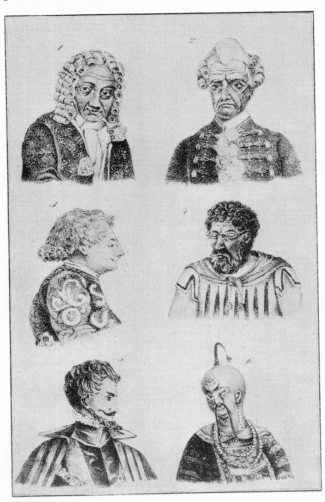

213, 214. Two plates from L. Schneider,
"Die Kunst, sich zu schminken", Berlin 1831·
Vienna, National Library.

PLATE 76

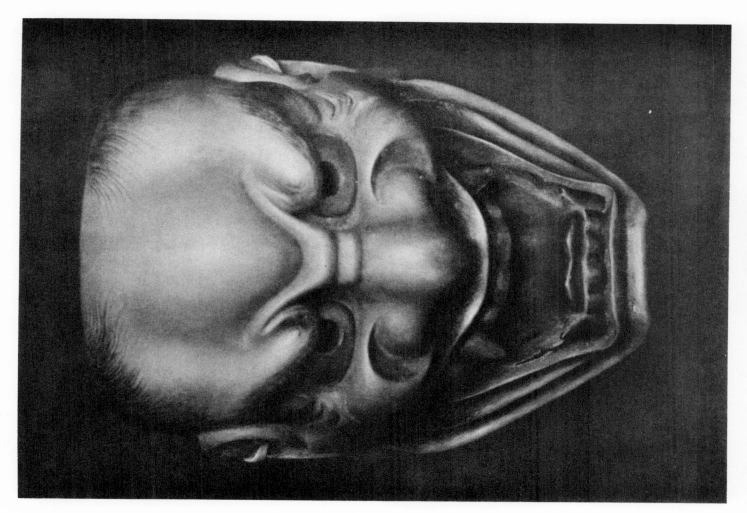

216. Kojischi-Mask.
Cf. Perzynski, "Japanische Masken" I, fig. 15.

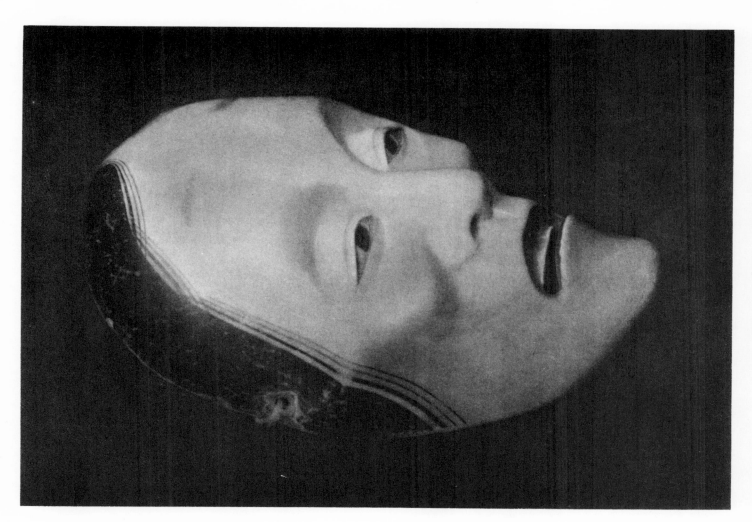

215. Jase onna (thin woman) Japan.
Cf. Perzynski, "Japanische Masken" II, p. 202

PLATE 77

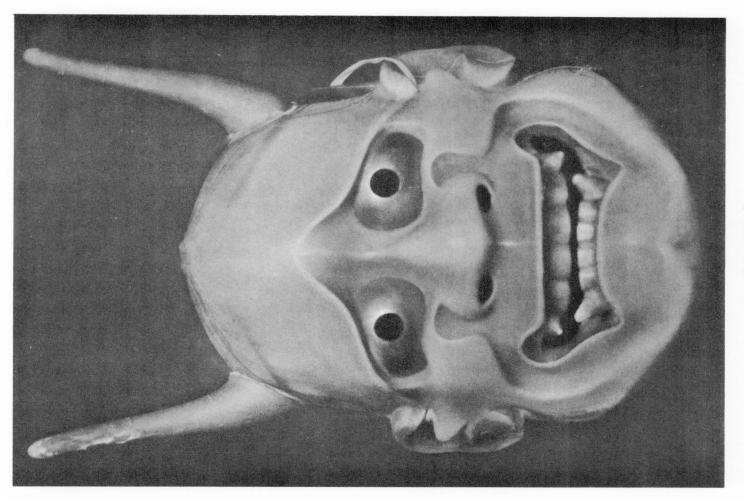

218. Hannya-Mask.
Cf. Perzynski, "Japanische Masken" I, Fig. 16.

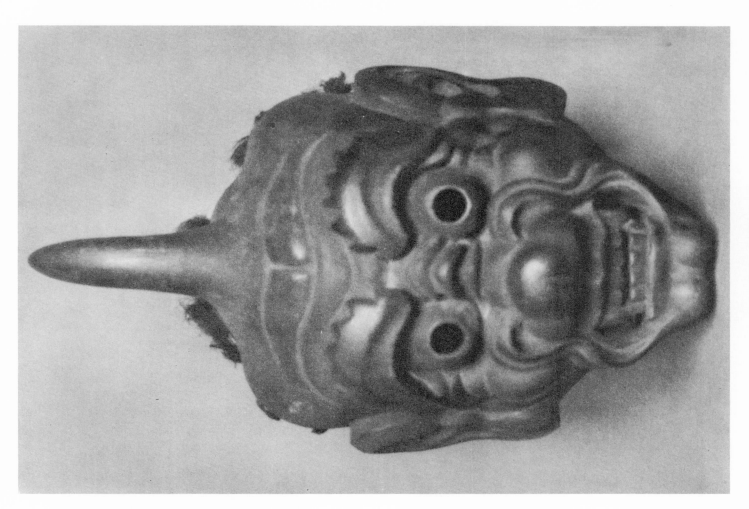

217. Japanese Mask.
Berlin, Museum für Völkerkunde.

PLATE 78

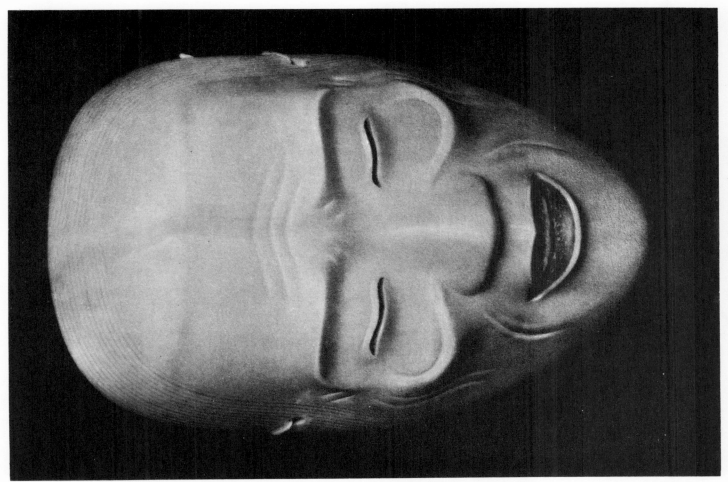

220. Uba Mask (elderly woman). Japan.
Cf. Perzynski. "Japanische Masken" II, p. 36.
Berlin. Museum für Völkerkunde.

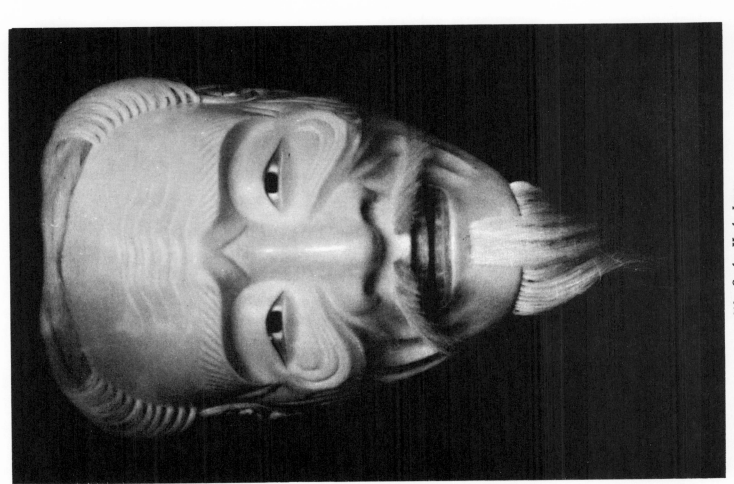

219. Sanko Mask, Japan.
Cf. Perzynski. "Japanische Masken" I, fig. 66
Berlin. Museum für Völkerkunde.

PLATE 79

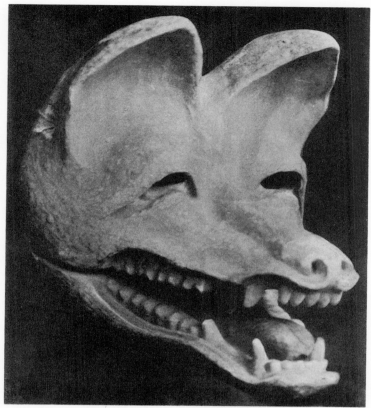

221. Fox mask (Kitsune). Kyogen.
Cf. Perzynski, "Japanische Masken" I, fig. 95.
Berlin, Museum für Völkerkunde.

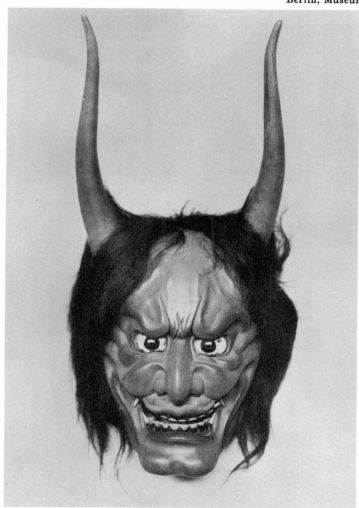

222. A Japanese Theatre Mask, Shinja.
Cf. Perzynski, "Japanische Masken" II, p. 124.

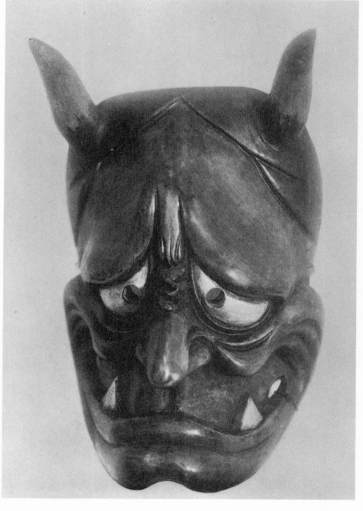

223. Japanese wooden mask. Kijo.
Cf. Perzynski, "Japanische Masken" II, 139.
Vienna, Museum für Völkerkunde.
Weltreisesammlung Ferdinand Este.

PLATE 80

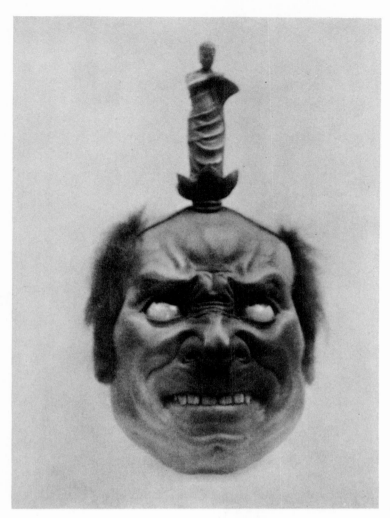

224. Figure of Demon and God, Japan.

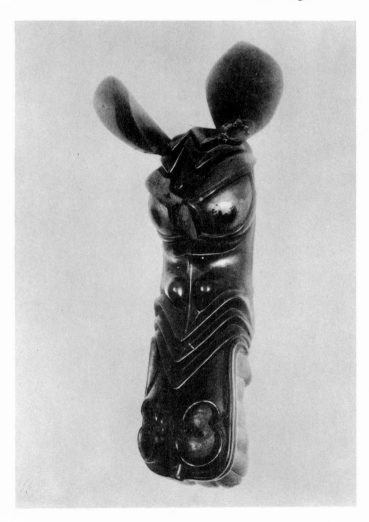

225. Paper-mâché horse mask, Japan.
Vienna, Museum für Völkerkunde.

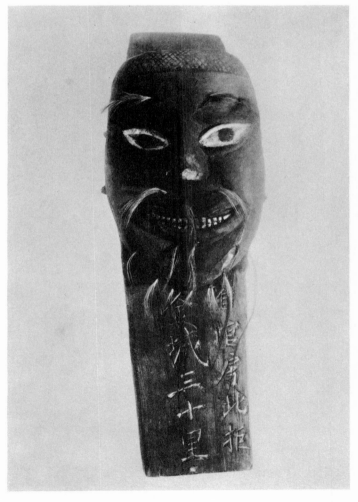

226. Head of a sign-post, in wood, Korea.
Vienna, Museum für Völkerkunde.

PLATE 81

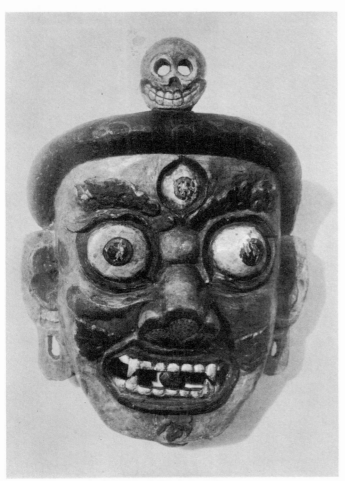

227. Wooden dance mask. Tibet.
Vienna, Museum für Völkerkunde.
Weltreisesammlung Ferdinand Este,

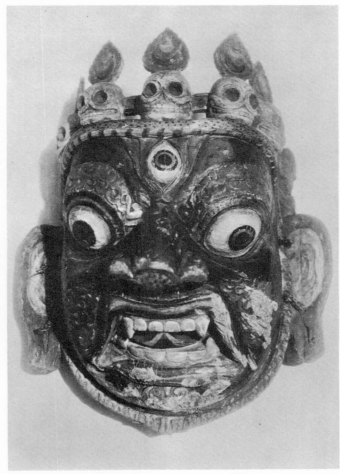

228. Wooden dance mask. Tibet.
Vienna, Museum für Völkerkunde.
Weltreisesammlung Ferdinand Este

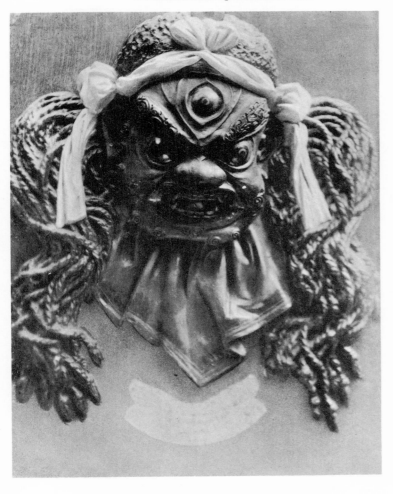

229. Three-eyed Demon Mask. Tibet.
Leyden, Rijks Ethnographisch Museum.

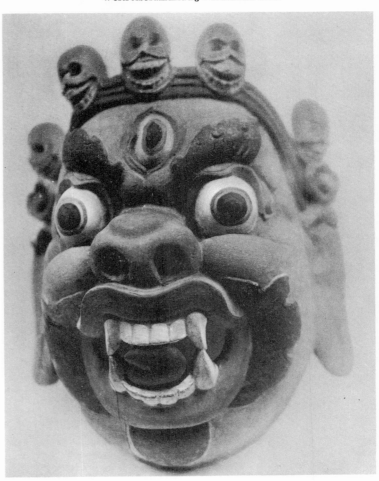

230. Demon mask. Tibet.
Leyden, Rijks Ethnographisch Museum.

PLATE 82

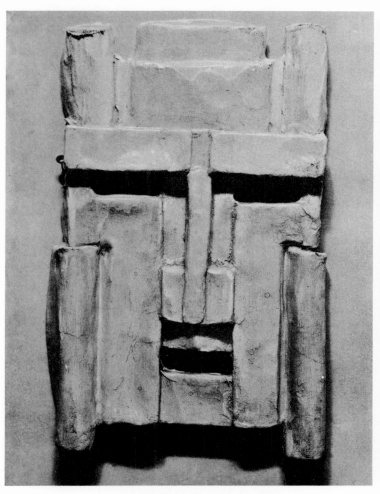

231. Emil Pirchan: Theatre Mask.
Cologne, Theatre Museum.

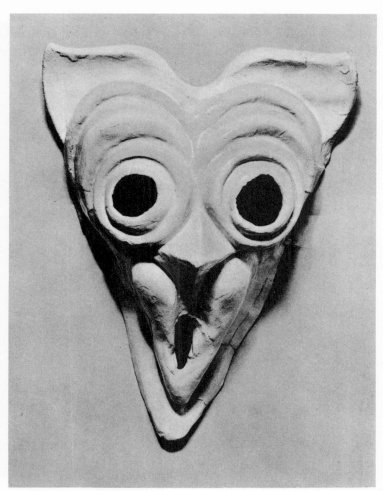

232. Emil Pirchan: Theatre mask.
Cologne, Theatre Museum.

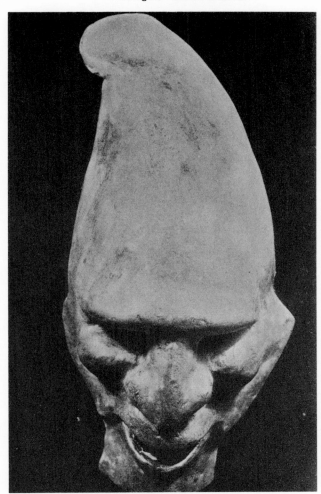

**233. Jan Hawermann: Mask for Stravinsky's
"L'Histoire d'un Soldat".**

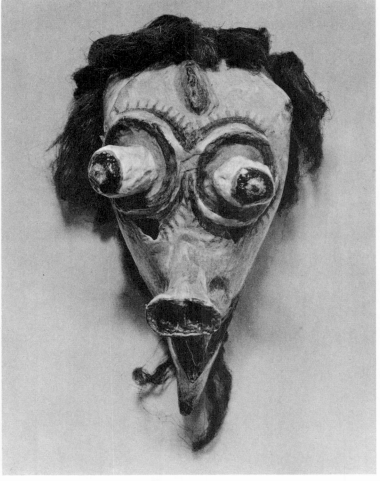

234. Herbert Keller: Mask.
Cologne, Theatre Museum.

PLATE 83

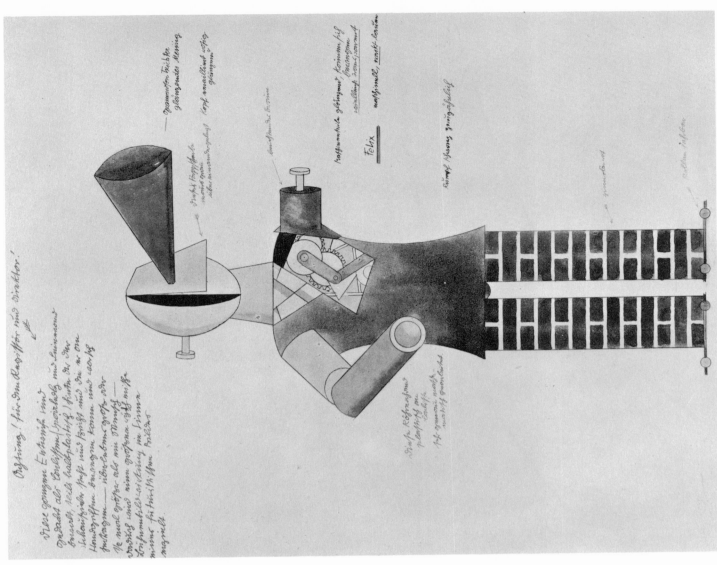

236. **George Grosz, Construction. 22**
Vienna, National Library.

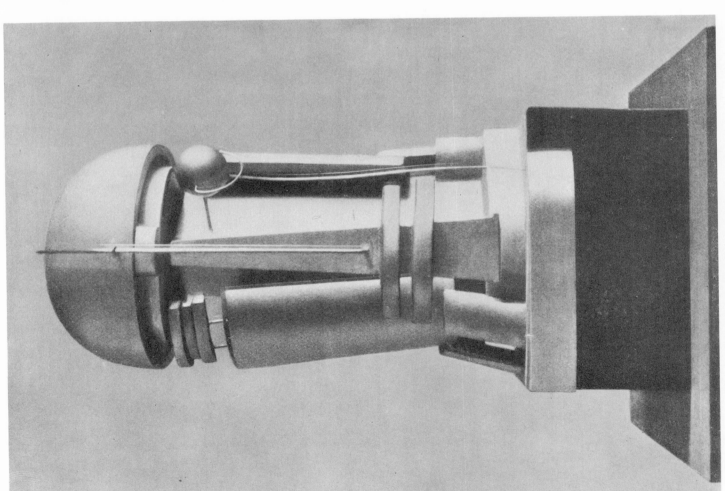

235. **Rudolf Belling: Sculpture. 1923.**

PLATE 84

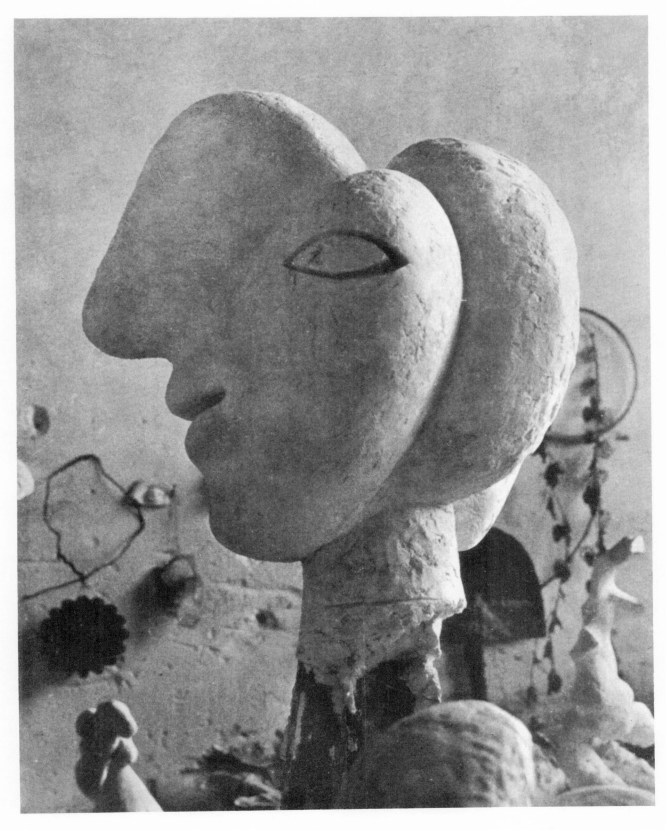

237. Pablo Picasso: Sculpture.

PLATE 85

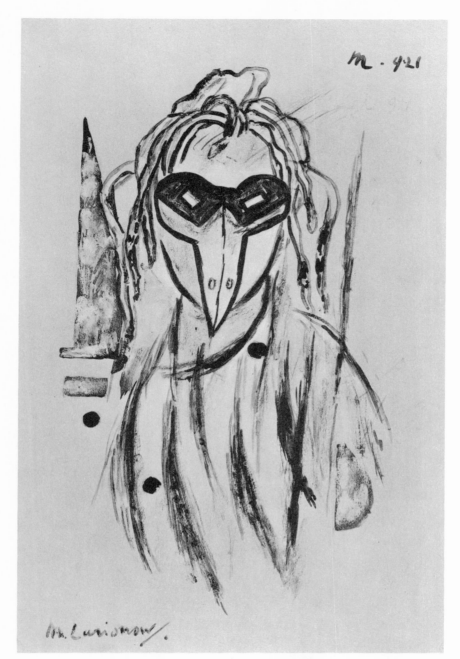

238. Michael Larionow: Bird Mask.

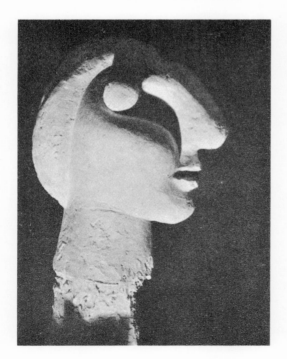

239. Pablo Picasso: Sculpture.

PLATE 86

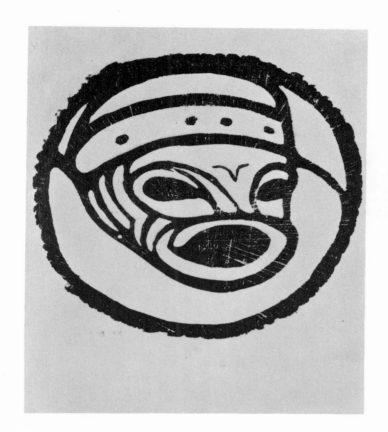
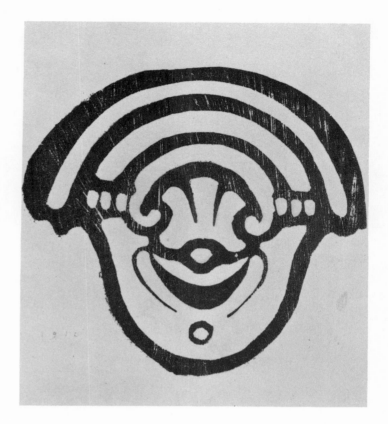
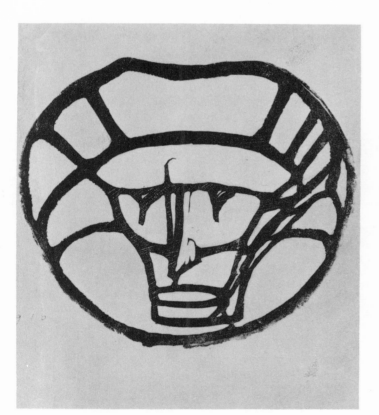
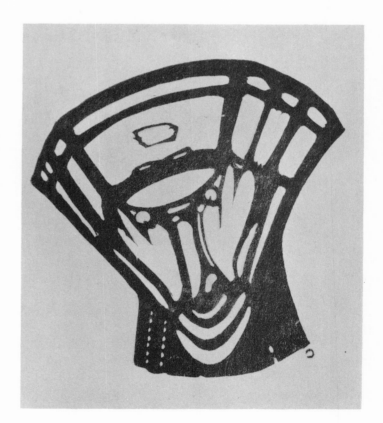

240—243. Edward Gordon Craig: Masks. Woodcuts.
Vienna, National Library.

PLATE 87

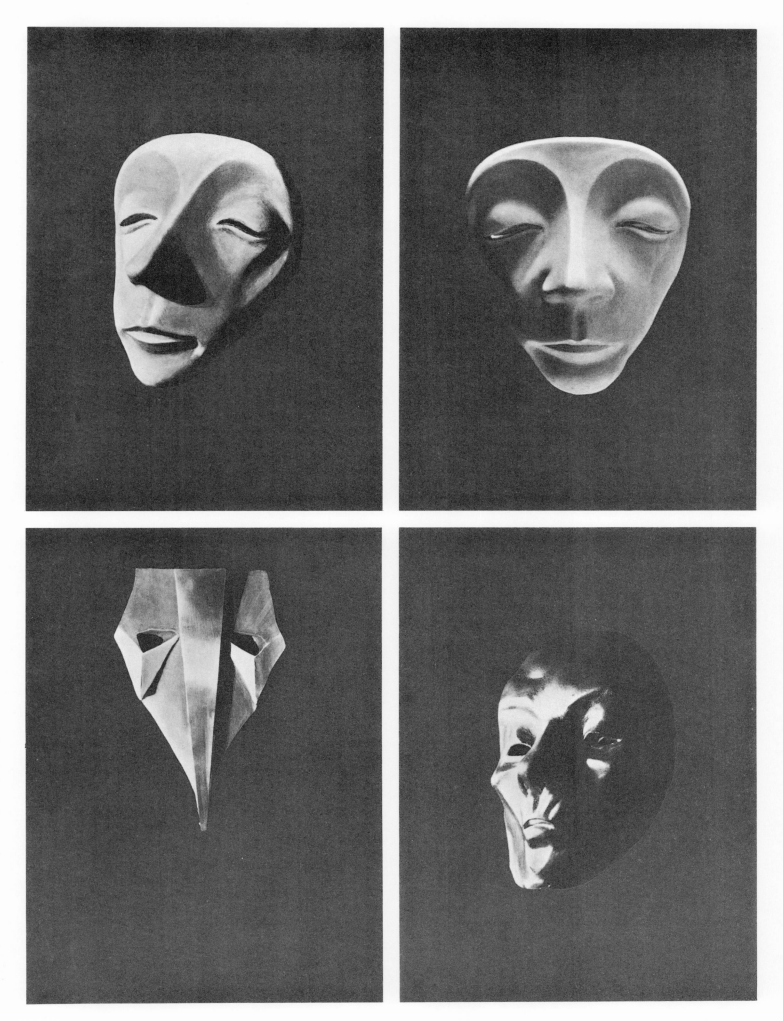

244—247. Taschme: Above: Mask of Mothers,
Below, left: Mask made of brass and painted wood;
right: Fairy Mask, gilded.

PLATE 88

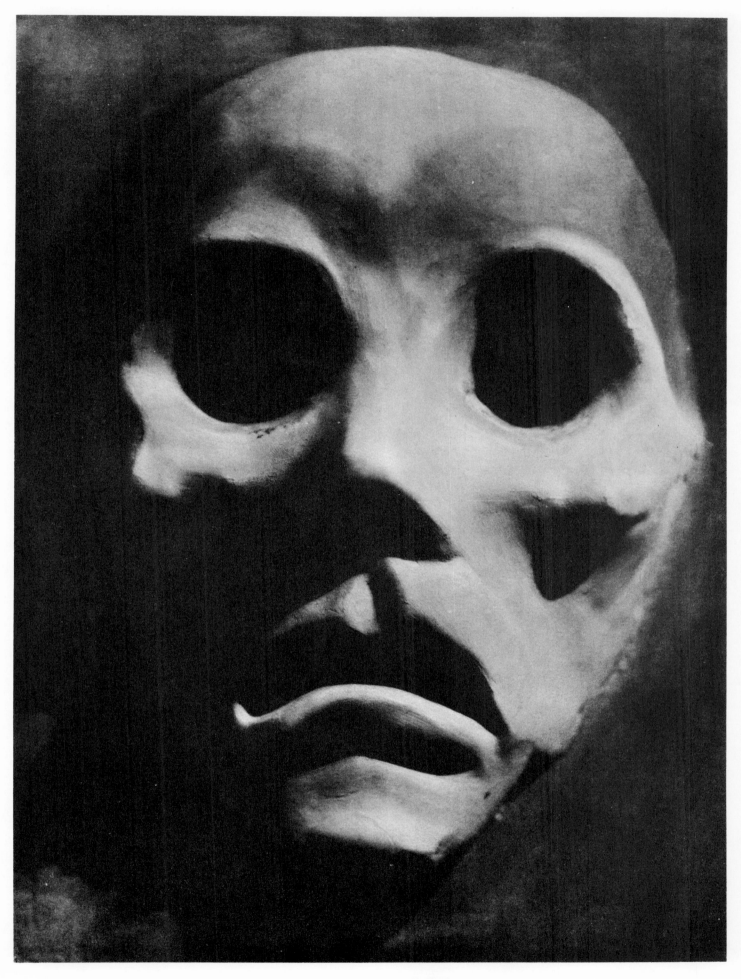

248. Taschme: Death Mask.

PLATE 89

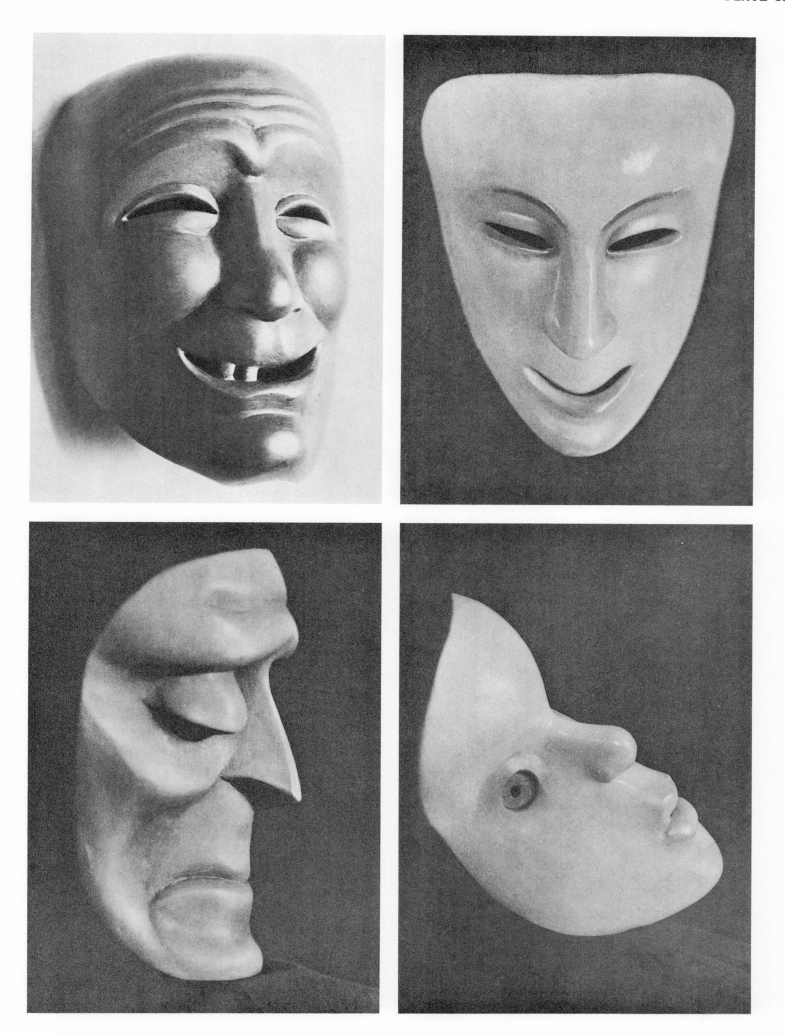

249—252. Marianne Heymann: Masks. Above, left,
Tunisian woman, right, a Girl; Below, left,
Old peasant (Death Dance), right, Sick child.

PLATE 90

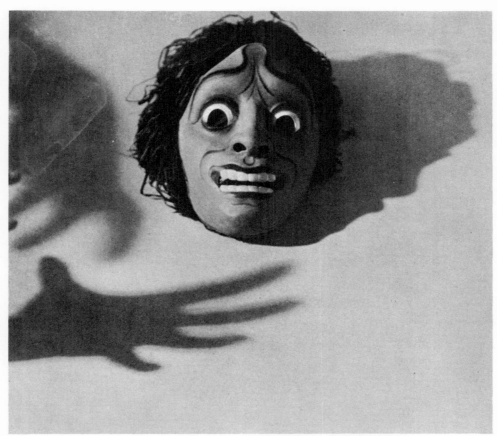

253. Richard Teschner: Dance Mask. Electra.

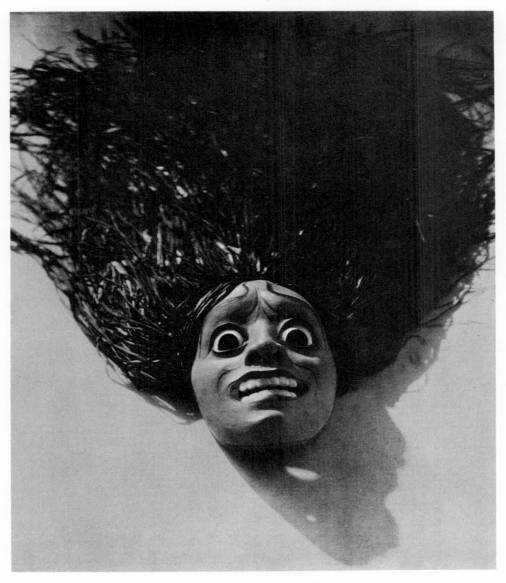

254. Richard Teschner: Dance Mask. Electra.

PLATE 91

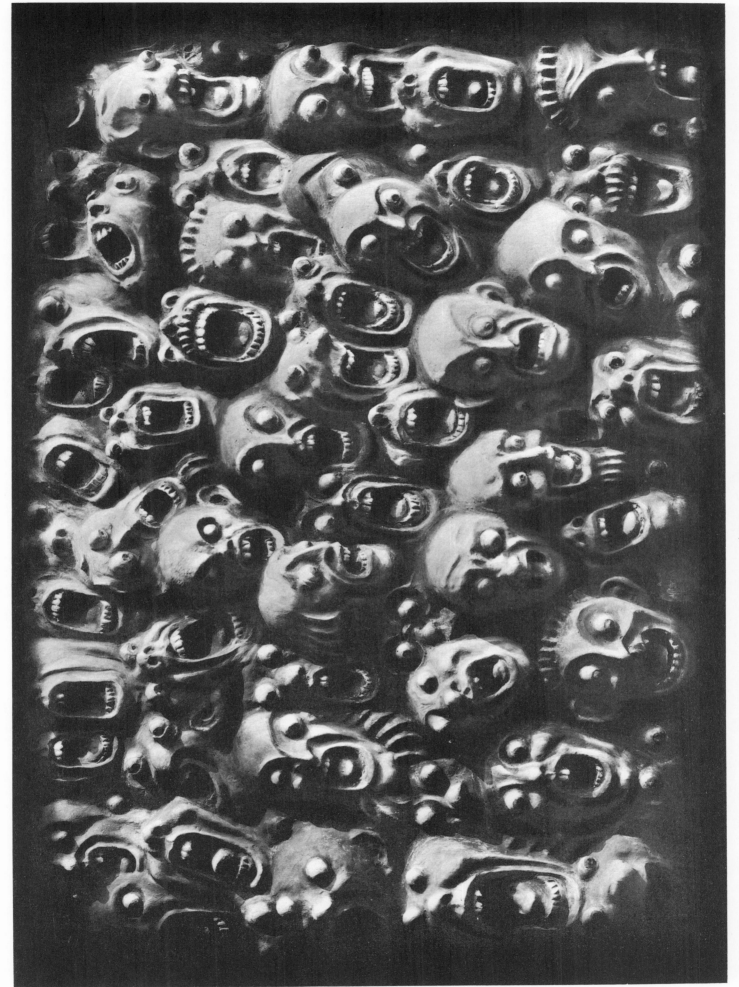

255. Sculpture, Arabella. "The Romance of a Horse"
(Westi-Film).
Vienna, National Library.
Film Section.